Zentangle® untangled

Inspiration and Prompts for Meditative Drawing

Kass Hall

NORTH LIGHT BOOKS
Cincinnati, Ohio

www.CreateMixedMedia.com

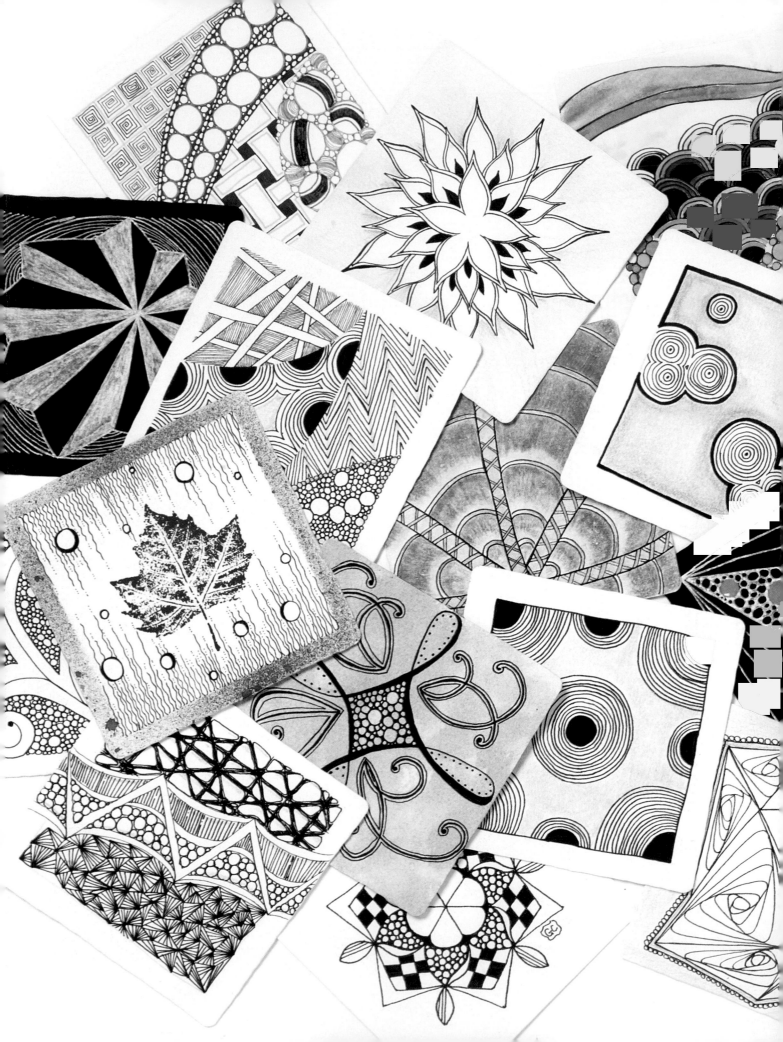

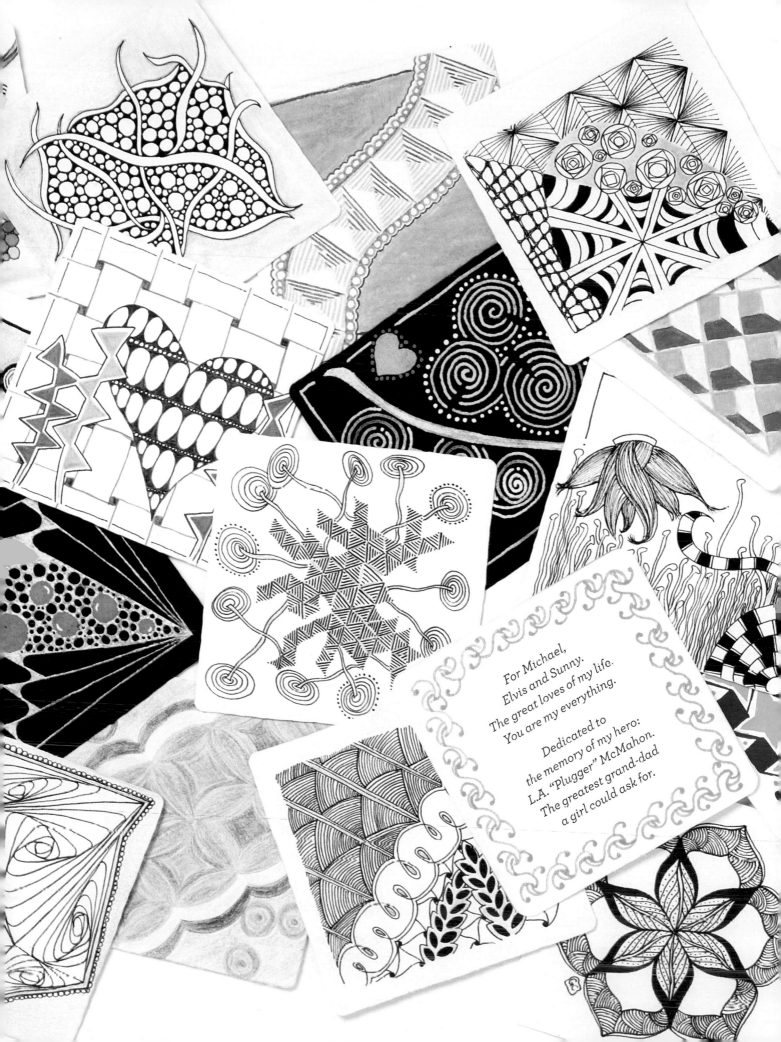

For Michael,
Elvis and Sunny.
The great loves of my life.
You are my everything.

Dedicated to
the memory of my hero:
L.A. "Plugger" McMahon.
The greatest grand-dad
a girl could ask for.

contents

Zentangle. It's a made-up word that many people have never heard, and those who have will tell you their thoughts on what it is.

"It's doodling." I've heard that a lot.

"I used to draw like that in high school." I hear that a lot, too.

"That is not real art." Not my favorite response.

I'm not going to sit here and tell anyone that they are wrong in their assumptions about what Zentangle is and why it's not what most people think. I believe that the best way to make my point is by showing you why it's different from anything you've seen or done before.

That said, for the uninitiated, Zentangle is *not* what you think. It's so much more.

And after I have convinced you of that, I'm going to show you new ways of creating Zentangle-inspired art.

Be ready to be inspired.

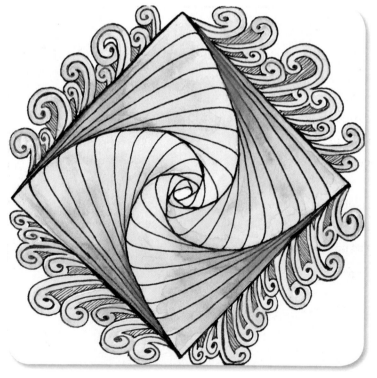

Introduction • watercolor, Sakura Pigma Micron pen

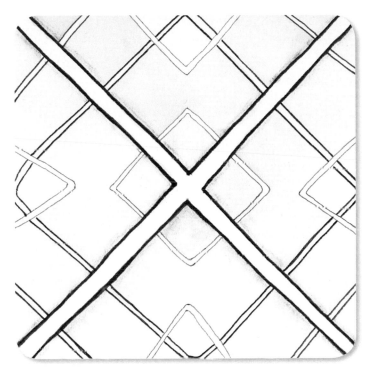

Brown Haze • Sakura Pigma Micron pen, watercolor pencil

Zentangle is the use of repetitive, basic pattern drawing. It is simple. It is achievable. And you don't even have to be able to draw. Why not, you ask? Because, actually, you can draw. Anyone can. You just need the tools and the know-how, and that's where this book comes in

Zentangle is about being thoughtful. Deliberate. Focused. You cannot rush Zentangle. It won't let you, because it forces you to stop, think about and feel what you're doing.

Zentangle can also be fast—it's realistic to find ten minutes in your day in which to complete a Zentangle artwork.

I often meet people who see my Zentangle-inspired artwork and tell me they can't draw, they aren't patient enough or they don't have the time to devote to creative activity. One of the great joys in being a Certified Zentangle® Teacher (CZT) is that I can prove them wrong and introduce them to a whole new world. A world of creativity. Confidence. Calm.

Zentangle is about embracing beauty—our own and that all around us. It is also about embracing the imperfections of life—in ourselves, in our world and, most important here, in our art. Like life, Zentangle is less than perfect. When my students worry that their lines are not straight, I ask them why they have to be straight. I ask them to find the beauty in the wonky lines they've drawn. It's initially difficult for many, but they all eventually find their way to acceptance of their art. Joyfully, this often leads to acceptance of themselves.

I think it's fair to say I was a crafty kid. I took craft classes on Saturday mornings, I made my own recycled paper and I made my own gifts for birthdays and Christmas. Was I artistically talented? Fair to say, not very! But I loved it, and that was all that mattered to me.

In 2009, I was completing both my Bachelor of Visual Art and Design degree and Graduate Certificate in Secondary Education university programs (things were busy!). Toward the end of the school year, I saw an article in *Cloth Paper Scissors* about Zentangle. Full of interesting drawings and color, it immediately caught my attention, and I soon discovered the online world of Zentangle.

Little did I know how my life was about to change!

Soon after, on a preplanned trip to New York, I contacted a local CZT, Robin Kraut, and we met in a coffee shop near New York University. Within minutes, I was a convert and proud owner of a Zentangle® kit. Our two-hour meeting became significantly longer!

My kit became especially important to me in 2010 when I went through a very difficult situation with my work and health; Zentangle® became my escape from the stress and anxiety I felt. I literally spent weeks at a time working on pages in a journal I had with preprinted photos of blank walls. It was the only thing I could do to stay focused and calm. I took my book and pen to restaurants, parties, doctor's appointments—anywhere. When I became stressed, I threw myself into my tangles and withdrew from the activities around me. What I didn't consciously realize at the time, but do now, is that I was using art as my therapy—and Zentangle sat firmly in the middle of that therapy. My psychiatrist thought it was magic.

Before I knew it, I was signing up to return to the United States to attend a Certified Zentangle® Teaching seminar, the training necessary to become a CZT. At that stage, there were no CZTs in Australia, and after the tumultuous year I'd had, it was something I needed to do. I felt it was a fulfilment of the journey I'd unwittingly begun the year before. I got on the plane, not knowing if this would simply be a neat wrap-up of my year or the beginning of something else.

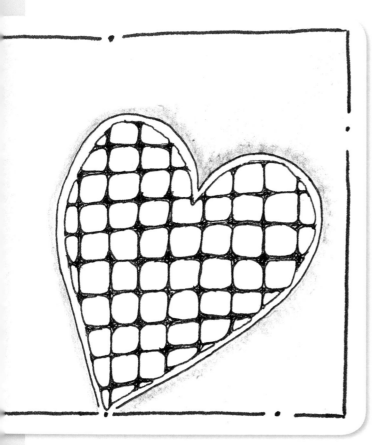

iHeart • Sakura Pigma Micron pen, graphite pencil

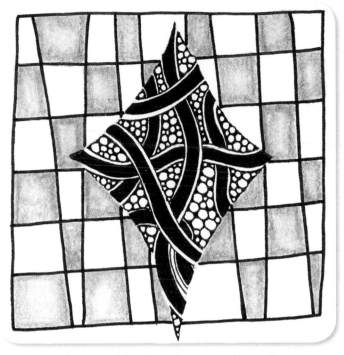

Diamonte · Sakura Pigma Micron pen, graphite pencil

You're now reading the result of that something else.

Since then, I've taught classes across Australia and New Zealand, from small classes all the way up to major expo crowds. It has been quite a ride, one that may never end, such is the importance of this wonderful drawing form in my life.

Zentangle remains therapeutic and relaxing for me. I've suffered from serious illness throughout my life. While producing the work in the pages that follow, I was diagnosed with cancer for the fourth time. Some days are harder than others, and I am lucky to have found an activity that can calm my mind and distract me from the realities of my life right now. I do struggle sometimes with illness, depression, mortality (all the fun stuff!). I am a mere

human after all. It's so beneficial that I can turn to Zentangle, focus my mind, find a relaxed place in my soul and remember: This is life. It is now. And despite everything, it's pretty awesome.

Zentangle has also brought many friends and kindred spirits into my life. Would I know them if not for the Internet? If not for Zentangle? Definitely not, yet their love and support means so much. When I was diagnosed again, many friends provided artwork for this book to reduce my workload. Initially I didn't want contributors, but I can see now how much they bring to the pages that follow—and to me personally. I am so grateful for their generosity and talent, and I know you'll appreciate them, too, as you come across their work.

I have finally found an artistic home, a foundation for what else I do. I hope you might find similar enjoyment from it.

In the Beginning

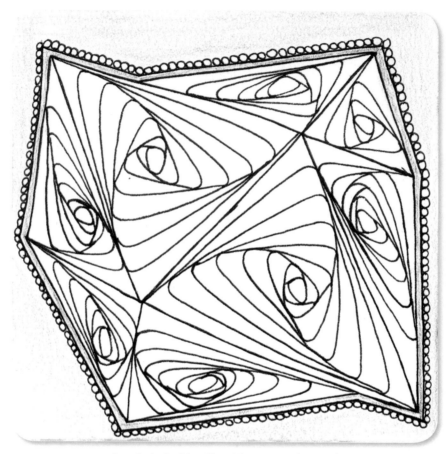

Paradoxical · Sakura Pigma Micron pen, graphite pencil

Beginning Zentangle is as easy as finding a pen and a surface. We'll look at specific materials in a moment, but for now just know that if you have a pen on hand and the surface stays still long enough, it can be tangled on. Imagine the possibilities of that!

Zentangle takes no special skills.

Can you draw a circle? It need not be a perfect one.
Can you draw a straight line —well, straight-ish? Great—you're
halfway there already. Bet you didn't think it was that easy!

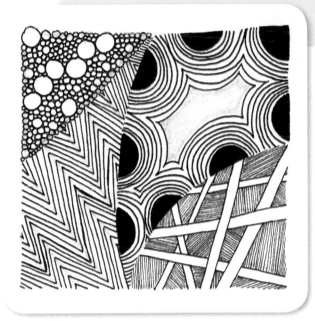

Starting Off · Sakura Pigma Micron pen, graphite pencil

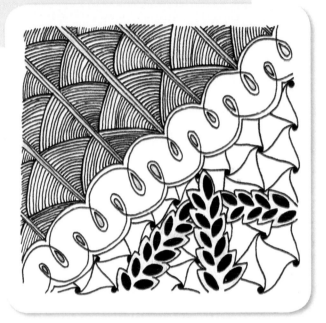

Moving Through · Sakura Pigma Micron pen, graphite pencil

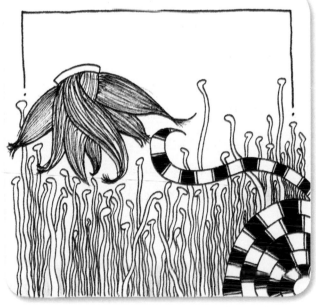

Beginning · Sakura Pigma Micron pen, graphite pencil

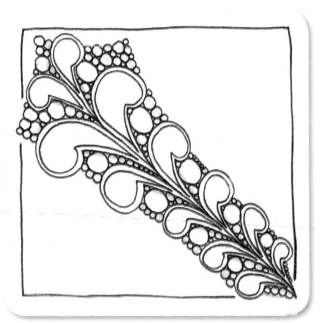

Flux · Sakura Pigma Micron pen, graphite pencil

Created in 2005, the Zentangle® concept was born when calligrapher Maria Thomas described to her partner the sense of focus, well-being and relaxation she felt while creating background patterns on a manuscript. A former Buddhist monk, her partner, Rick Roberts, recognized this state as one of meditation. Together they worked toward creating a system that would teach and encourage others to experience the same sensations.

In the years since, the Zentangle concept has developed a worldwide following, with Certified Zentangle® Teachers in more than a dozen countries and active communities online.

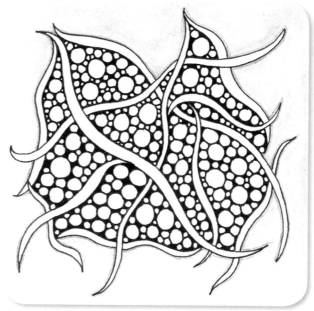

Mysteria · Sakura Pigma Micron pen, graphite pencil

Zentangle Facts

- There are 110 "official" Zentangle® patterns.

- There are more than three hundred Certified Zentangle® Teachers in locations across the globe, including North America, Europe, Asia and Australia.

- Zentangle is being used with people from age 5 to 105.

- Zentangle has been used successfully in schools, hospitals, assisted-living facilities, mental health facilities and more.

Zentangle materials really are the finest materials available. Although there is flexibility in all things Zentangle-related (there are definitely no limits or rules!), the materials you use often reflect the value you put into what you are creating. It is nice to use lovely art materials, right?

Traditional Zentangle tiles are made from Fabriano Tiepolo printmaking paper. It is a 100 percent cotton, mold-made paper that is then cut to Zentangle tile size using a handmade die. In 2011, the black Zentangle tile was introduced, which is an Arches Cover paper, also made from 100 percent cotton.

To partner these papers, Zentangle formed a relationship with Sakura, the Japanese pen maker.

Until I discovered Zentangle, I had never used the Pigma Micron pens—now I use almost nothing else! They work with the Tiepolo paper so beautifully, causing no bleed and drying to a fade-proof and waterproof finish. And their gel pens are fantastic on the black tiles, as you will see in the images throughout this book.

The original Zentangle® kit (pictured) is made from handmade Nepalese paper, in line with the founders' beliefs supporting sustainable, ecologically sound production of art materials. Your Zentangle® kit is much like carrying around your favorite book—over time it may become a little worn with love. This is part of the charm!

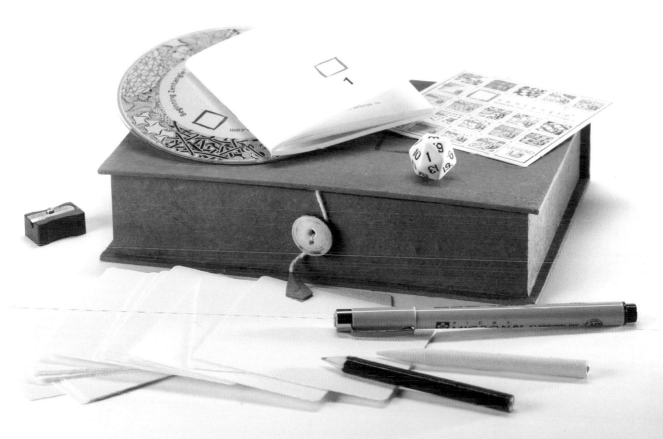

Zentangle® Kit · Includes: Zentangle® tiles, Sakura Pigma Micron pens, a Zentangle® pencil, pencil sharpener, 20-sided dice and legend, instruction booklet

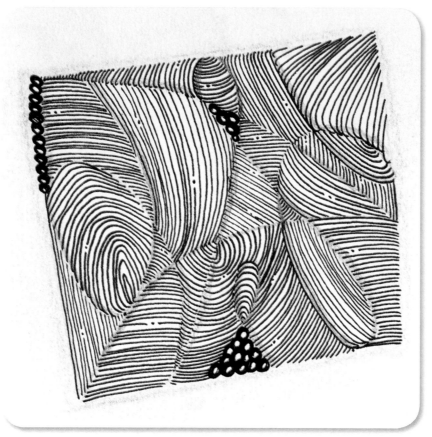

Isochor • Sakura Pigma Micron pen, graphite pencil

I'm now going to share with you the big secret about Zentangle.

It's not about the patterns.

In fact, the patterns do not "belong" to anyone; many have origins in history and the natural world. Many have been derived from things that have been seen. No one really owns the patterns—or tangles, as we call them. They are not what makes Zentangle unique.

The secret of what makes Zentangle unique is the teaching method. It's about the why of what we do and the how, as opposed to the what. It's the knowledge that Rick and Maria, as well as the CZTs, possess that you cannot get anywhere else—not in this book or any other. You get the foundation of Zentangle® by learning from a CZT because we are able to talk in a language and in terms that have been developed to create something different. We explain how to draw the basic shapes, but we also talk about the materials, how to maximize them and where the beauty of Zentangle comes from. It's something we learn because it has infiltrated our hearts. And, when we share that knowledge with you, it gets into your heart, too.

And THAT is where the beauty of Zentangle lies— within YOU.

Visit www.createmixedmedia.com/zentangleuntangled for extras.

So what does the beauty inside have to do with relaxation and focus?

Well, when you start learning the whys and hows of Zentangle, you begin to discover what is inside. You become connected to it. Being connected brings an inner peace, and you begin to relax. This is the Zen that Rick first recognized in Maria.

You become engrossed in what you're doing. You shut out the noise and the busyness around you. You focus completely on the tile you're working on, on the shape of the pen strokes. You think about the way you hold the pen. You think about the texture of the paper. In its beauty, you find your own, and you begin to allow your body to relax and focus on what you have at hand.

Many people use Zentangle to help them relax before sleep or to settle classrooms full of children after lunch. Many (including myself) use it to relieve anxiety during difficult times.

But the one thing that threads us all together, the thing that Zentangle brings to us all, is beauty.

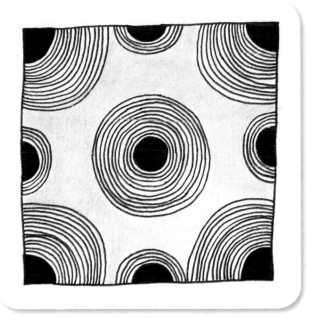

Twilight Zone • Sakura Pigma Micron pen, graphite pencil

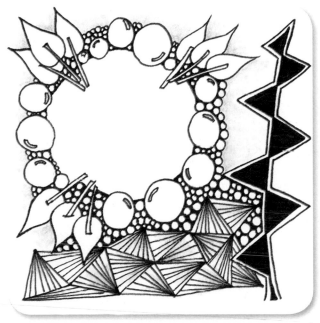

Organic • Sakura Pigma Micron pen, graphite pencil

Sign up for the free newsletter at www.createmixedmedia.com.

15

Let's Get Our Tangle On

I'm excited to present twelve tangle patterns for you to learn. Four of these tangles are official Zentangle® patterns that you might otherwise learn from a CZT, so sharing them here is very exciting. We also have some new patterns from other CZTs, as well as three by yours truly. I hope you enjoy incorporating these tangles into your art! And don't forget that your local CZT can teach you dozens more tangles, or there are great online resources to continue learning from, too.

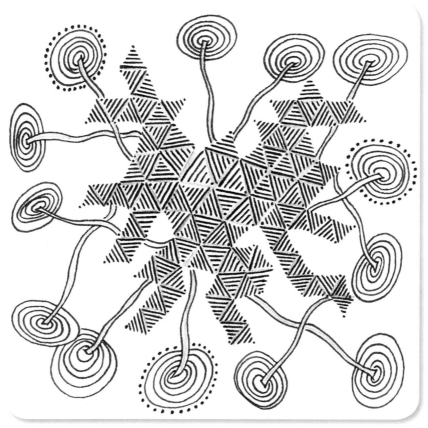

Matrix · Sakura Pigma Micron pen, graphite pencil

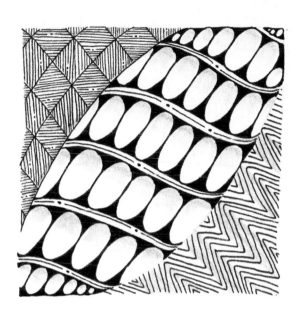

Orb · Sakura Pigma Micron pen, graphite pencil

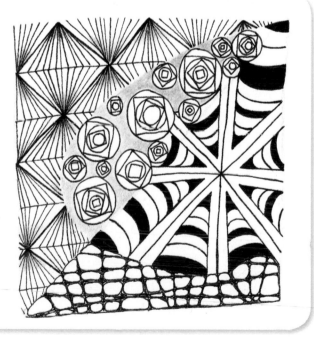

In The Zone · Sakura Pigma Micron pen, graphite pencil

CABIN FLOOR

Chari-Lynn Reithmeier, CZT

When we went to the Zentangle® certification seminar, we looked around the grounds for inspiration to design our own tangles. Chari-Lynn Reithmeier designed *Cabin Floor*, inspired by the floors at Amherst. It's an easy tangle that can be used as a fantastic background tangle or "filler."

materials

Sakura Pigma Micron pen (.01 Black) • **Graphite pencil** • **Fabriano Tiepolo printmaking paper (3½" [8.9cm] tile)**

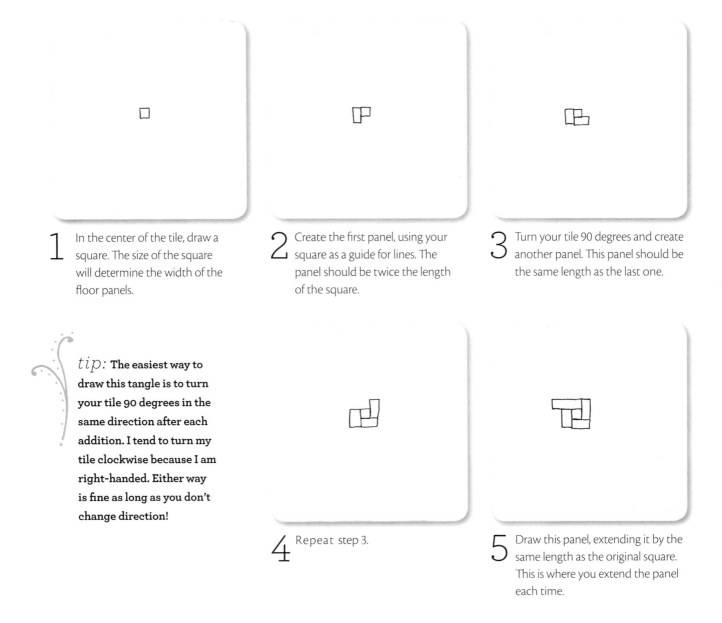

1 In the center of the tile, draw a square. The size of the square will determine the width of the floor panels.

2 Create the first panel, using your square as a guide for lines. The panel should be twice the length of the square.

3 Turn your tile 90 degrees and create another panel. This panel should be the same length as the last one.

tip: **The easiest way to draw this tangle is to turn your tile 90 degrees in the same direction after each addition. I tend to turn my tile clockwise because I am right-handed. Either way is fine as long as you don't change direction!**

4 Repeat step 3.

5 Draw this panel, extending it by the same length as the original square. This is where you extend the panel each time.

Visit www.createmixedmedia.com/zentangleuntangled for extras.

6 Continue to add panels until your tangle reaches the desired size.

7 To close off the square shape of the tangle, draw your last panel the same length as the one next to it (you can see how I have done this on the top right corner of the tangle).

8 Shade your tangle as desired. I like to gently shade the corners of the tangle because this gives some dimension to it. You may choose something different, like shading the outer panels only.

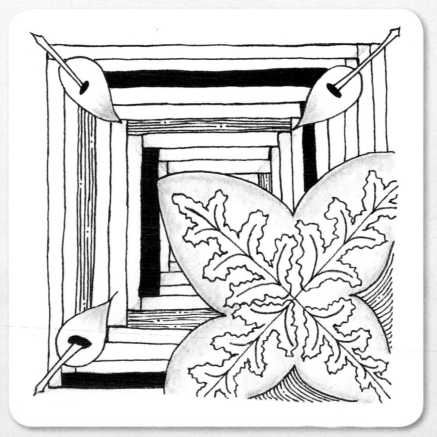

Cabin Floor · Sakura Pigma Micron pen, graphite pencil

Sign up for the free newsletter at www.createmixedmedia.com.

19

FIVE-OH

Kass Hall, CZT

Five-Oh is a tangle that I created while dreaming of my next Hawaiian holiday. It is inspired by the big wave surf on Oahu's North Shore. I'm also a fan of the TV show **Hawaii Five-0** (the new version), but felt the retro look of the tangle was also an acknowledgment of the original series.

materials

Sakura Pigma Micron pen (.01 Black) • **Graphite pencil** • **Fabriano Tiepolo printmaking paper (3½" [8.9cm] tile)**

1 Create your pencil border on your Zentangle tile.

2 Draw 3 long, thin bars in various lengths with rounded edges from one side of the tile. In the example, I have chosen to draw left to right, but there is no reason you cannot adapt this to any direction.

3 Draw another fine line around each bar, doubling the bar. Your bars will become wider and rounder at the ends as you add more lines.

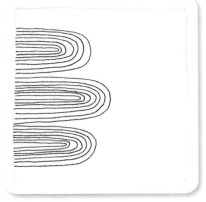

4 Continue to add more lines until each wave meets up.

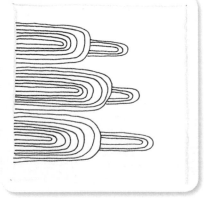

5 Once each wave has connected, start a new wave on the end of the existing waves. These, too, should be various lengths.

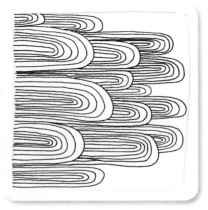

6 Continue building new waves at various heights until you feel that the waves are complete.

Visit www.createmixedmedia.com/zentangleuntangled for extras.

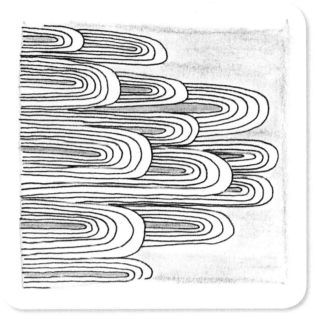

tip: **Make the bars different lengths for visual interest, like waves coming into the shore. The unevenness is part of the beauty.**

You can start them at the very middle of the arc, but also try putting them off-center. If you look at my example, some second and third waves are centered and some are not. When you move from the center, some lines might extend down the side of your first waves. This is fine; in fact, it gives the tangle a better sense of ocean waves.

7 When you have finished your waves, shade your tangle, remembering that the areas you shade will make the immediate white areas around it pop out more. See *Shading Zentangles* for tips about shading.

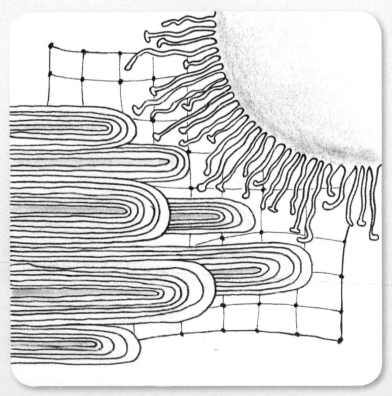

Waikiki Delight · Sakura Pigma Micron pen, graphite pencil

Sign up for the free newsletter at www.createmixedmedia.com.

21

STARFISH

Kass Hall, CZT

Starfish is an easy tangle that was inspired by collage pages I have by mixed-media legend Teesha Moore. Being another ocean-inspired tangle, it will work beautifully with *Five-Oh*.

materials

Sakura Pigma Micron pen (.01 Black) • Graphite pencil • Fabriano Tiepolo printmaking paper (3½" [8.9cm] tile)

1 Create your pencil border on your Zentangle tile.

2 Create a 5-point pentagon using curved lines inward. These don't need to be perfectly even, but do try to keep them relatively even. I practiced this with pencil on scrap paper until I was able to draw the shape consistently.

3 Connect 2 points of the pentagon using a cone shape.

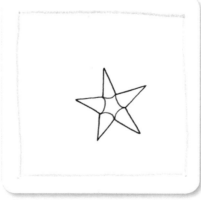

4 Repeat step 3 until you have a 5-point star shape.

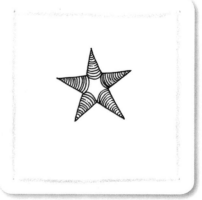

5 Fill the arms of the starfish with lines. I used curved lines to run parallel with the original pentagon shape, but the finished example shows other options. Anything goes!

Visit www.createmixedmedia.com/zentangleuntangled for extras.

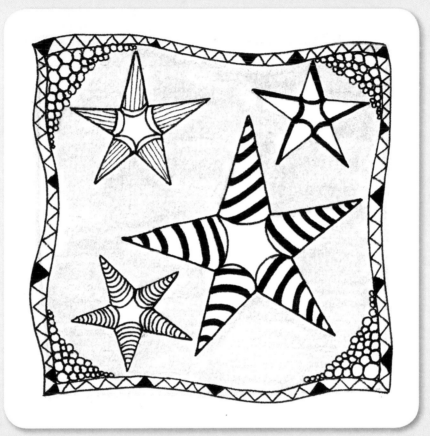

Starfish · Sakura Pigma Micron pen, graphite pencil

ECHO

Sue Clark, CZT

I met Sue in 2010 at the Certified Zentangle® Teacher seminar in Massachusetts. This is one of my favorite tangles, and I am so pleased that Sue has allowed me to share it with you.

materials

Sakura Pigma Micron pen (.01 Black) • **Graphite pencil** • **Fabriano Tiepolo printmaking paper (3½" [8.9cm] tile)**

1 Create your pencil border on your Zentangle tile.

2 Create a grid of dots on your tile. I have 6 across and 5 down.

3 Draw lines across the tile, halfway between the dots, but leave a small gap between each line. These will look like the division sign in mathematics.

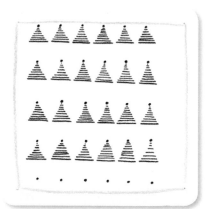

4 Starting at the top dot, draw increasingly longer lines until you meet the middle line. The result will look like a cone. Do this to all of your dots.

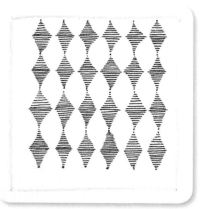

5 Turn your tile 180 degrees and repeat step 4.

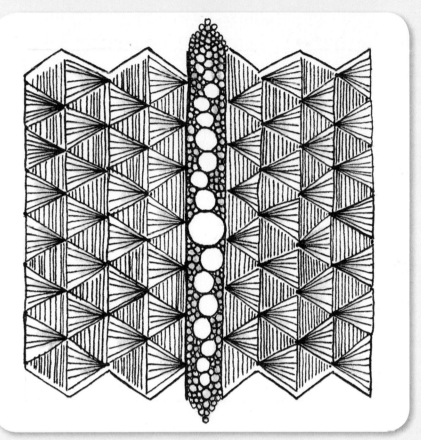

Echoing Munch · Sakura Pigma Micron pen, graphite pencil

BRONX CHEER

Official Zentangle®

I think this is the easiest tangle ever designed, and almost one of the most fun! Maybe it's the Yankees fan in me, but I just love a Bronx cheer! It's called *Bronx Cheer* because it is designed to look like a raspberry.

materials

Sakura Pigma Micron pen (.01 Black) • **Graphite pencil** • **Fabriano Tiepolo printmaking paper (3½" [8.9cm] tile)**

tip: **Bronx Cheer is fantastic for covering up big mistakes because the berries are rough and colored in.**

1 Create a long, fine stem.

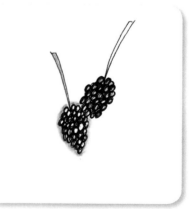

2 Create your first berry at the base of the stem. Berries should be rough-looking. Go over your circular lines several times so only a little bit of white shows through the center of the berry.

3 Create more berries until you feel the raspberry is complete.

4 Use your pencil to shade the raspberry as desired. You might decide to shade the berries themselves or around the edges.

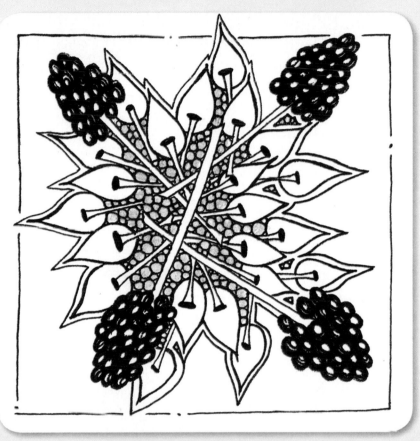

Au Naturale · Sakura Pigma Micron pen, graphite pencil

CHEERS

Sue Clark, CZT

Another very popular tangle from Sue Clark, CZT, *Cheers* is an easy tangle that can stand alone or form the basis for something more complex.

materials

Sakura Pigma Micron pen (.01 Black) • **Graphite pencil** • **Fabriano Tiepolo printmaking paper (3½" [8.9cm] tile)**

1 Create your pencil border on your Zentangle tile.

2 In the center of the tile, draw the corners of a square, leaving a gap in the center of the sides of the square.

3 Link the gaps using a small, semi-circle shape.

4 Draw the corners of a square outside of the shape you drew in step 3.

5 Repeat the corners you added in step 4 with semicircles.

6 Repeat steps 4 and 5 several times.

Visit www.createmixedmedia.com/zentangleuntangled for extras.

 tip: You can, after a couple of repeats, simply draw a single line instead of breaking the shape down as shown. However, my experience is that the shape is better held by breaking the lines rather than drawing one ongoing line. Do whatever works best for you.

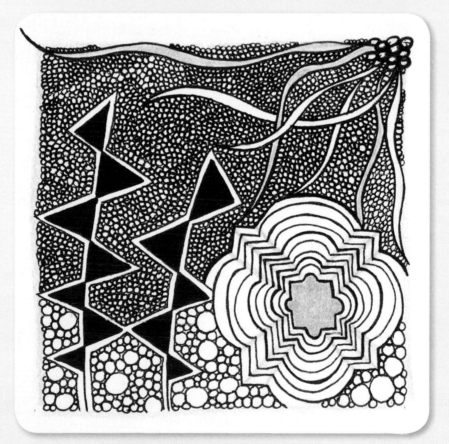

Cheers · Sakura Pigma Micron pen, graphite pencil

MOOKA

Maria Thomas—Official Zentangle®

Mooka was introduced in 2010 after Maria Thomas was inspired by the art of Alphonse Mucha, the Czech artist most noted for his art nouveau paintings and decorative art. When I first saw *Mooka*, I thought it seemed overly complicated, but in fact it is very easy. It has become wildly popular since its introduction..

m a t e r i a l s

Sakura Pigma Micron pen (.01 Black) • Graphite pencil • Fabriano Tiepolo printmaking paper (3½" [8.9cm] tile)

1 Draw a curved line and bring the line back down parallel with the first. Keep the curve relatively close, but do not close them off. This will be your largest curve.

2 Using the end of your second line, create a new curve in the opposite direction.

3 Create your third curve in the same direction as in step 1, remembering to keep the curve smaller and within the last.

tip: **Remember that your second line on the curve will always be the *inner* line. Refer to the example for guidance.**

4 When you have reached the center of the *Mooka* tangle, simply create one small curve with an emphasized dot on the end.

Visit www.createmixedmedia.com/zentangleuntangled for extras.

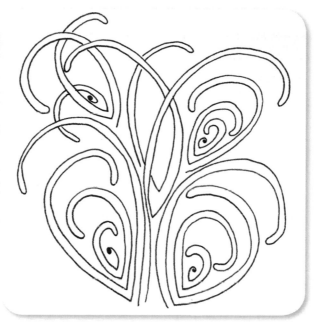

Once you have the general concept down, you can vary the angles and curves of *Mooka*, as I have done here.

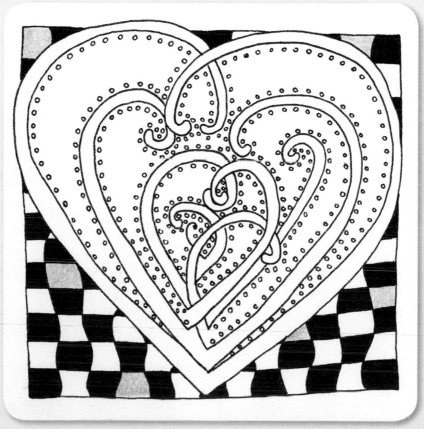

Love, Mooka · Sakura Pigma Micron pen, graphite pencil

Sign up for the free newsletter at www.createmixedmedia.com.

31

FACETS

Nancy Pinke, CZT

Nancy Pinke, CZT, created this tangle in 2010, and it's fantastic because it brings a unique illusionary look to your Zentangle practice. After you feel confident with it, you can adapt it as you wish in so many ways.

Note: The instructions I give here differ from those I've seen online. The final tangle is the same, but this technique was more logical to my mind. Check out the Zentangle® newsletter archives for the alternative method.

materials

Sakura Pigma Micron pen (.01 Black) • **Graphite pencil** • **Fabriano Tiepolo printmaking paper (3½" [8.9cm] tile)**

1 Create your pencil border on your Zentangle tile.

2 Draw two lines at equal distance apart across your tile.

3 Turn your tile 90 degrees and repeat, creating a 9-square grid on your tile.

4 In the first column of your grid, draw a diagonal line in a zigzag style back-and-forth across the three squares. Repeat the zigzag line in the next column, drawing the mirror image of the first row's line. The third column should repeat the zigzag line in the first column.

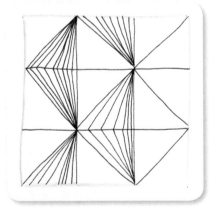

5 In the left-hand column, draw lines running parallel to the diagonal line created in step 4, but converge at the lines at the top and the bottom of the diamond shape. For now, only draw your lines on the left-hand side of the diamond. Depending on how close together your lines are, you'll probably fit 5 to 7 lines per side. Do this for all columns.

tip: **This tangle can be a little disorienting if you are not focused, so try to concentrate and don't put pen to tile until you're sure you're going in the right direction!**

Visit www.createmixedmedia.com/zentangleuntangled for extras.

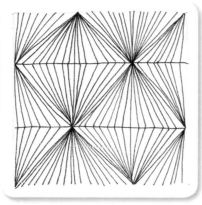

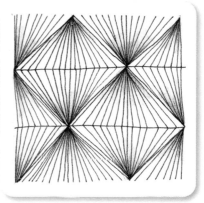

6 Repeat step 5 for the right-hand side of each diamond.

7 Shade your *Facets* from the point of each diamond. *Note: A tortillion or paper stump is ideal to shade this tangle toward the center.*

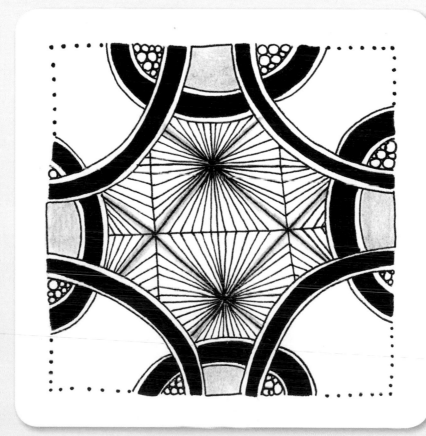

Facets of Life · Sakura Pigma Micron pen, graphite pencil

Sign up for the free newsletter at www.createmixedmedia.com.

33

HONEYCOMB

Kass Hall, CZT

I designed *Honeycomb* when I wanted to create a background for an artwork. It took some working out, but I think it's a fantastic tangle that can be easily adapted to create something unique in your work.

materials

Sakura Pigma Micron pen (.01 Black) • **Graphite pencil** • **Fabriano Tiepolo printmaking paper (3½" [8.9cm] tile)**

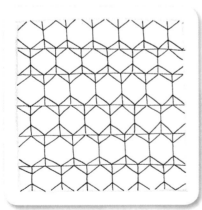

1 Create your pencil border on your Zentangle tile.

2 Draw evenly spaced lines across the tile—about 5 should fit nicely, but this will depend on how big you want your honeycomb to be.
Then turn your tile 90 degrees and draw lines across to give your tile a "square brick" appearance.

3 Across each row, connect the bottom third of each vertical line to the corners of the square beneath it. The pattern will begin to look like roofs on houses. Do this to all of the squares.

4 Turn the tile 180 degrees. Repeat step 3. You'll see a zigzag effect take shape across your tile.

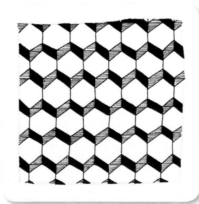

5 Fill in the zigzag effect as desired. My suggestion is to solidly color one direction and put a pattern (I've used fine lines) in the other.

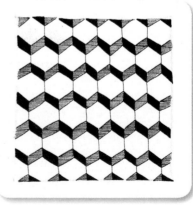

6 Shade as desired. I suggest choosing one part of each shape (for example, the left-hand side) and shade that area in each hexagon.

Visit www.createmixedmedia.com/zentangleuntangled for extras.

tip: **This tangle really comes to life with shading. See more details about shading in *Shading Zentangles.***

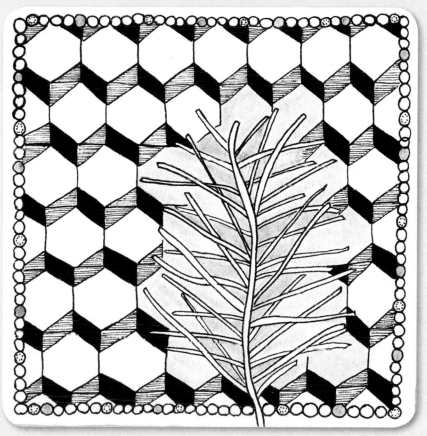

Honeytree · Sakura Pigma Micron pen, graphite pencil

FRIPPERY

Melissa Hoopes, CZT

I remember the day I got the email from my friend Melissa saying she had a tangle for this book. I opened the attachment and thought, "Uh-oh." It looked difficult. So I had a try—and it isn't difficult. In fact, I love it. *Frippery* just takes some practice.

Note: About ten Zentangle tiles went to the big paper mill in the sky as I practiced this tangle. May I suggest you try it first on something a little more economical when practicing this tangle!

materials

Sakura Pigma Micron pen (.01 Black) • **Graphite pencil** • **Fabriano Tiepolo printmaking paper (3½" [8.9cm] tile)**

1 Draw 2 curved, parallel lines with your pencil. With your pen, starting in the middle of the 2 pencil lines, draw a diagonal line to the top line. Change direction and draw a diagonal line to the lower pencil line. In a continuous pen stroke, create a loop under the lower line and take it back up to the middle to the same level you began.

2 Return to the original starting point, and draw 2 lines to complete the diamond. This leads to repeating the pattern created in step 1.

3 Continue to repeat the pattern and completing the diamonds until it reaches the desired length.

4 On the inside of each diamond draw a smaller diamond.

5 Decorate as desired. Melissa drew a circle inside the inner diamond. Then she added a cross in the middle of the circle and filled in around the circle.

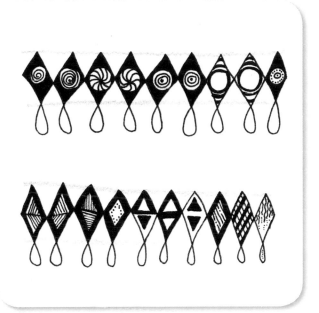

tip: **If you find the curved lines a bit of a stretch to begin with, use straight lines like I have in the variations tile. This may help you get the feel for *Frippery*.**

Here you can see some variations that Melissa provided, as well as a few of my own.

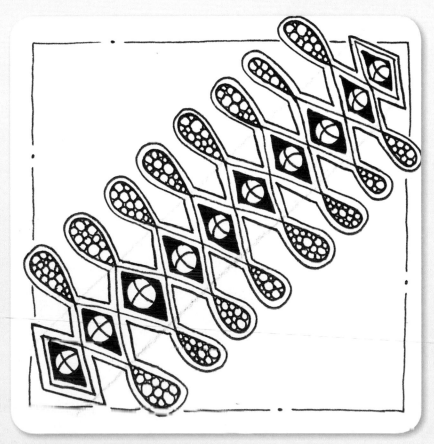

Frippery Eh · Sakura Pigma Micron pen, graphite pencil

Sign up for the free newsletter at www.createmixedmedia.com.

37

TRIPOLI

Maria Thomas—Official Zentangle®

Tripoli is another tangle introduced in 2010 and is proving immensely popular around the world. Using the basic shape of a triangle, I slightly curve the triangle points because it builds a wider pattern and illusion.

Making consistent sizes and finding the correct angles on the triangles is the secret to success with this tangle—if perfection is important to you. If not (and remember that Zentangle embraces the imperfections of art, as it does life!), then go for your life!

materials

Sakura Pigma Micron pen (.01 Black) • **Graphite pencil** • **Fabriano Tiepolo printmaking paper (3½" [8.9cm] tile)**

1 Draw a small triangle just off center of your tile.

2 Draw another triangle the same size next to it, so the bases of the triangles almost meet. Leave a fine gap between the two sides.

3 Repeat step 2 until you create a circular shape of triangles. You need to draw 6 triangles.

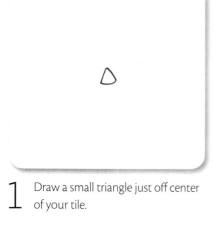

4 Create a mirror image of each triangle on the outer side of each one in the circle.

5 To the right of each mirrored triangle, draw another triangle in the opposite direction. This should leave enough space for another triangle to its right, between the one you just added and next mirrored triangle.

6 Place any additional triangles as desired and fill in the triangles as desired.

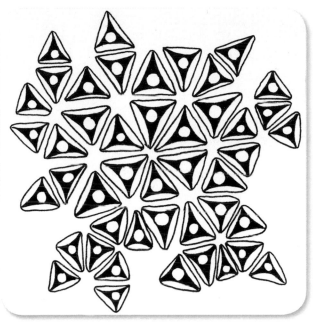

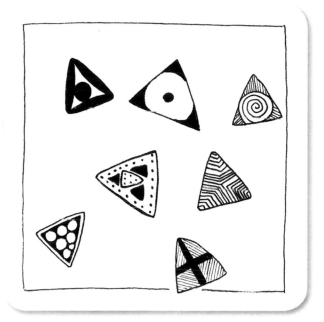

A finished example of *Tripoli* with larger triangles and the same drawn-in pattern.

Play with other ideas for patterns.

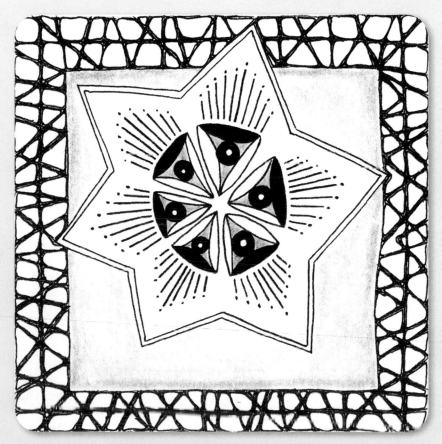

Tripoli Star · Sakura Pigma Micron pen, graphite pencil

Sign up for the free newsletter at www.createmixedmedia.com.

39

BETWEED

Official Zentangle®

I decided to include *Betweed* in the book because my students often ask me about it. People either understand this tangle or they don't. Once you get it, it's fantastic to adapt and play with.

materials

Sakura Pigma Micron pen (.01 Black) • **Graphite pencil** • **Fabriano Tiepolo printmaking paper (3½" [8.9cm] tile)**

1 Create your pencil border on your Zentangle tile.

2 Create an L-shaped line on your tile.

3 From a short way up the vertical axis, draw a line to the end of the horizontal line. I put a slight curve in mine, but a straight line is fine, too.

4 On the line you just drew, start a short way in from the vertical axis and draw a straight line to the top of the axis line. You can curve it if you wish.

5 Repeat steps 3 and 4. Remember to start just up the last line you drew; each new line starts from the line just drawn, and they should all converge at the end of an axis point.

6 Continue as desired or until the lines look like they'll flatten out.

Betwixt and Betweed · Sakura Pigma Micron pen, graphite pencil

(1)

(2)

(3)

Static · Sakura Pigma Micron pen, graphite pencil

Shading is an integral part of completing your Zentangle. For the first year of tangling, I did not shade my work because I couldn't do it "right" and it conflicted with my inner perfectionist. When I took my Zentangle® Certification Teaching class, I learned how to shade properly, and now I never do a black-and-white tangle without it. It now looks naked.

The trick with shading is to understand that it takes the area shaded into the background. It gives your work dimension. So if you want a particular spot to stand out, don't shade it—shade around it.

That said, there really is no right or wrong way to shade your tangles. Each of us takes a different approach, and that's part of the beauty of this art form—everything you do is OK and part of what makes your work unique. Don't use your eraser; just go with your instinct and see what happens. You will not be disappointed!

I've used a basic tangle, called *Static*, in the example (1). I've left the first example (1) blank so you can see the difference shading creates. In the second example (2), I've run my pencil in straight lines over the points of each zigzag. Looking at it carefully, you'll see this gives a distinct appearance of peaks and troughs, not unlike drawings of mountain ranges. Comparing it to the unshaded example (1), you can see how that light use of pencil adds something quite interesting to the tangle and changes the appearance of it dramatically.

In the third example (3), I've used the same theory, but only shaded lines with the points facing one direction. This small change in approach brings yet another appearance to the tangle.

Some tanglers also choose to shade one static line crosswise. Experiment and play, remembering the darker areas will fade to the background.

The tangle I've used in this example is called *Huggins* and is one I use often.

Again, I've left the first example (1) without shading so you can get a feel for the difference shading makes and the different applications for it.

In the second example (2), I've created a checkerboard effect by shading the weaves that go in one direction. Just looking at that example, you can see the white, unshaded weaves really pop; they appear closer to the eye than the shaded parts. This particular tangle lends itself well to this type of blocked shading.

For a subtler look, check out the third example (3) and how I have gently shaded along the lines. I added the shading on the inside of the short ends of the weave. This gives the appearance that the outer sides of the weave have shading, too. It also gives the weaving dimension and makes it look like a real basket weave.

As you look through the samples and galleries in this book, some will be shaded and some will not. Really examine how we've done this and apply it to your own artwork. You cannot get it wrong. Play with shading until you feel comfortable, and remember that, like all art media, practice brings confidence.

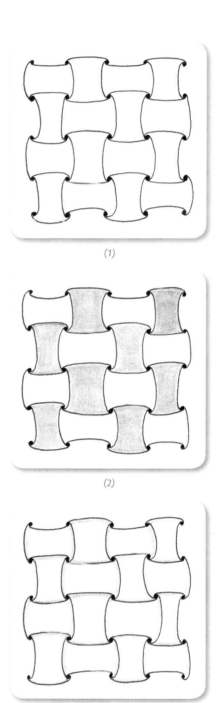

(1)

(2)

(3)

Huggins • Sakura Pigma Micron pen, graphite pencil

Sign up for the free newsletter at www.createmixedmedia.com.

43

Tint on Black · black Zentangle® tile, Sakura Souffle pens

Black Zentangle® tiles are a relatively new product so when I bought some, I decided to test out my various pens. These are the Sakura Souffle pens and I used the *Pokeleaf* tangle so I could try a few different colors and see how they worked out. As you can see, they look fantastic; they become brighter as they dry. Watch out, black paper—I'm coming for you!

White on Black 2 · black Zentangle® tile, Sakura Souffle pens

White gel pens are not made equal. Some look great on black paper, some not so much. So I tested the white Sakura Souffle pen on a black Zentangle® tile and it looks amazing! These take a little longer to dry than regular gel pens, but I also think the result is superior to the countless others I've tried.

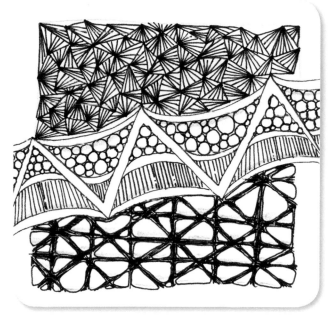

Country Twang · Sakura Pigma Micron pen, graphite pencil

The official tangle across the middle of this piece, *Twing*, inspired the name of this tile. My parents are big country music fans so it seemed apt, and I think the two tangles on either side complement their personalities—simple yet complicated! Love you Mum and Dad!

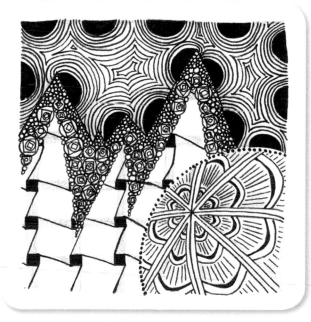

Mountain · Sakura Pigma Micron pen, graphite pencil

This tile started with me playing with strings, and I wanted to see how I could combine curved and straight lines into the string effectively. *Mountain* was the outcome.

Sign up for the free newsletter at www.createmixedmedia.com.

45

Black-and-White Zentangle Gallery

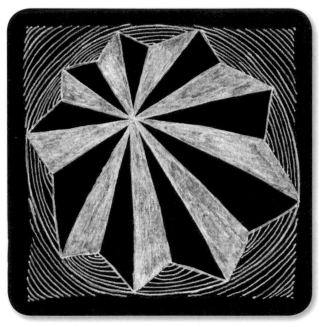

Gneiss · black Zentangle® tile, white gel pen

Gneiss is an official tangle and in this particular piece, uses a black Zentangle® tile and a white gel pen. The strength of this piece is how well the white Sakura Gelly Roll pen looks on the black tile; the effect is fantastic despite having done nothing more than reversing the coloring of a regular Zentangle (black ink on white tile).

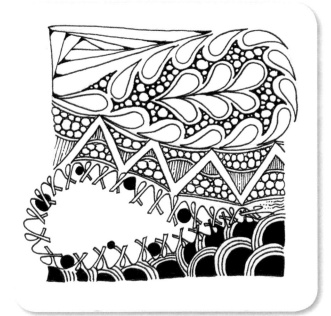

Angels vs. Rangers · Sakura Pigma Micron pen, graphite pencil

Here is a tangle that began while watching television, and obviously while I was watching baseball. Although I wasn't consciously thinking about it, it's interesting that the raindrop shape on top looks like angel wings (L.A. Angels) and the tangle around the lower raindrop shape looks like a ranch fence (Texas Rangers)! Who says Zentangle doesn't creep into our subconscious thinking?

 (For the record—I'm a Yankees fan through and through.)

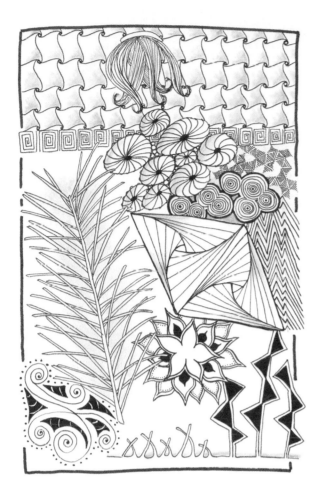

Musings · Sakura Pigma Micron pen, graphite pencil

I wish I could tell you a story about this particular journal page, but it was one of those pages that simply happened. I sat watching television with my journal, started tangling, and this is what came out. No rhyme, no reason—but a great journal page nonetheless.

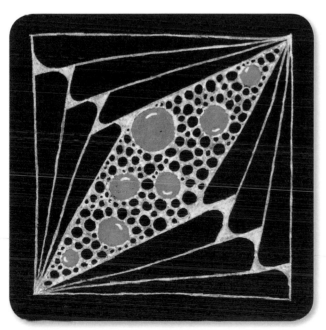

Moonshine · black Zentangle® tile, Sakura Souffle pens

Another black tile with white ink, but this time adding the black Souffle pen (which is more gray) for some effect without stepping away from the black-and-white premise. These Sakura pens take a little while to fully dry, but I think you'll agree they are worth the wait!

Sign up for the free newsletter at www.createmixedmedia.com.

47

Black-and-White Zentangle Gallery

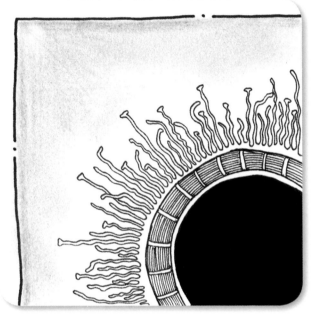

Quabog is an official tangle that you don't see used a lot, but I like to use it, especially when I am depicting the sun. The song "You Are My Sunshine" is such a sweet tune, it seemed like an appropriate title for this piece.

You Are My Sunshine · Sakura Pigma Micron pen, graphite pencil

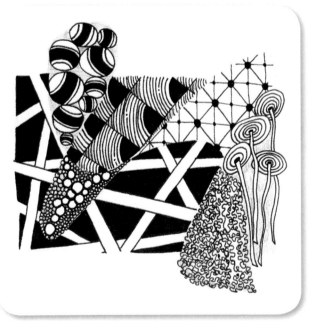

Today is a Zentangle I must have created when I was having a chaotic day—the busy, unbalanced nature is obviously reflecting my state of mind! That's OK, we all have days like this, and it's definitely OK when our Zentangle art reflects that!

Today · Sakura Pigma Micron pen, graphite pencil

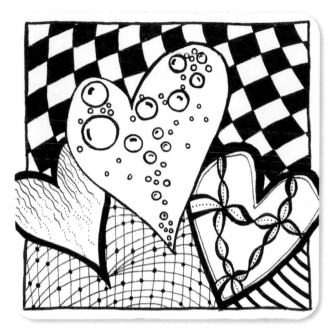

Falling In Love · Sakura Pigma Micron pen, graphite pencil

There's nothing more wonderful than love, is there? I love heart shapes, and although I am not the most romantic girly-girl in the world, I am grateful for love every day. This tile is a simple one, and being about love it makes me think of my husband, Michael, who embodies unconditional love. I'm so lucky.

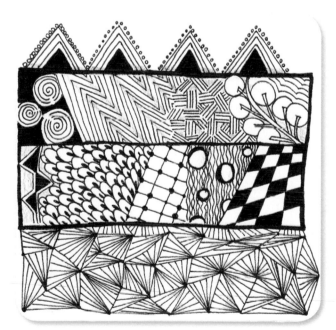

September Blue · Sakura Pigma Micron pen, graphite pencil

Our seasons are a little "upside down" here in Australia, and it's September when we start seeing the first blue skies of springtime. I know many of us live every day through winter waiting for that first glimpse of September blue sky.

Sign up for the free newsletter at www.createmixedmedia.com.

49

Color Me Happy

Color! If I could start all over again, I would go to art school and specialize in the history and theory of color. I'd learn about the origins of color, investigate how colors interact with each other, study how we respond to them and explore every other possible facet of the topic I could muster. To me, color is infinitely fascinating.

Rainbow · watercolor, micron pen

I'm aware this makes me a bit of a nerd, but as an artist, I think understanding color is essential to successfully practicing art. And it is not that hard to pick up the basics. A wide range of resources are available (hello, Pantone!), and getting these down will help you add color to your Zentangle, artwork, home and life.

In Zentangle terms, color is a bit of an unknown value, because as CZTs we don't initially bring color into our teaching. Color is not addressed in the Zentangle® kit or any official materials.

Why is that? Well, it's simple really. We want to keep your introduction to Zentangle as simple as possible and then give you creative wings to fly off and add whatever you want to your Zentangle-inspired art. In our classes we talk about the simplicity of Zentangle and its achievability to all. Can you imagine if we then said, "And now choose which shade of red you'd like to use?" It would be overwhelming. So we keep it black and white (with shading). Then, when you feel ready to explore adding colors, you're free to do so. This is where I hope this book will help you.

I'm not a color expert, but I have read and studied a lot, and my years of artistic experience inform many of my color choices. I know what I like and what works for me. The beauty is that color means different things to and evokes different emotions in everyone. Use the color that works for you. I feature red in my work regularly. I love using different shades and tints of red to draw attention to particular parts of my work. Red also matches just about everything, so you'll see it a lot in the pages of this book. Don't be afraid of color. It is pure bliss to simply play with color and discover new combinations. Your palette will emerge naturally over time.

Snail Trail · micron pen, Inktense blocks

In color theory, we are guided by the color wheel, an example of which I have created. In simple terms, we have three types of color: primary color, secondary color and tertiary color.

The primary colors (red, blue and yellow) are colors that cannot be created by mixing; these are our foundations. When we mix two of these primary colors, we create secondary colors (green, violet and orange).

Pretty straightforward, right? These two concepts are further explained as you turn the page.

You'll see how these colors relate to each other by looking at the color wheel. Tertiary colors are those that appear between the primary and secondary colors on the wheel. They are produced when one of the colors makes up a greater part of the mix, usually the primary color.

With color mixing, always start with the lighter color first and progressively add the darker color until you get the mix you want. You can always deepen the color, but lightening it is much harder. Much of this comes down to experimentation and practice, but that's half the fun of color play. I heartily recommend you create your own color wheel (or purchase one from your local art supplier) as a reference. It will be an invaluable resource as you get more into your art practice.

Ready to dive in a little deeper?

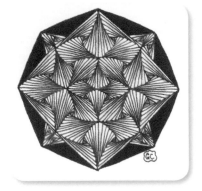
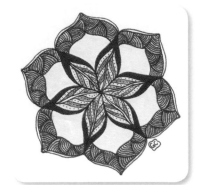
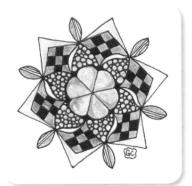
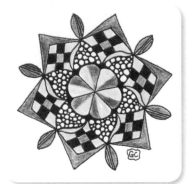
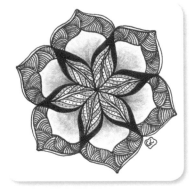
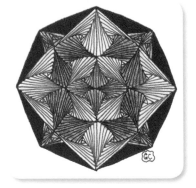

Blue Heaven · White cardstock, Prismacolor pencils

by Geneviève Crabe, CZT

Lakers · White cardstock, Prismacolor pencils

by Geneviève Crabe, CZT

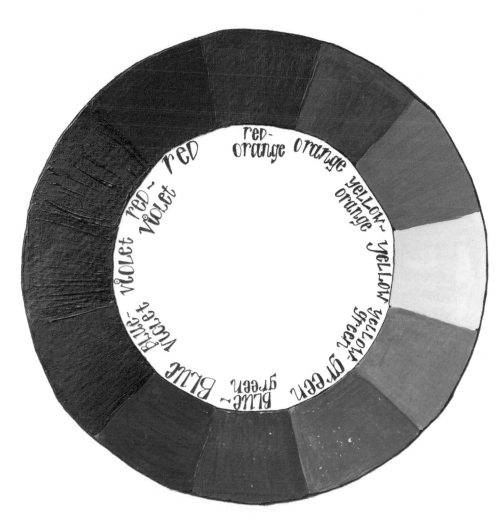

red-orange orange yellow-orange yellow yellow-green green blue-green BLUE BLUE~violet violet RED~violet RED red-orange

the
COLOR
WHEEL

acrylic paint, Sakura Pigma Micron pen

Sign up for the free newsletter at www.createmixedmedia.com.

53

No doubt you learned early in school that the primary colors are red, blue and yellow. They are the basis for mixing the other colors on the wheel and cannot be mixed from other colors. They sit evenly apart on the color wheel and work together beautifully. One of the most famous uses of these primary colors is Piet Mondrian's *Composition* series.

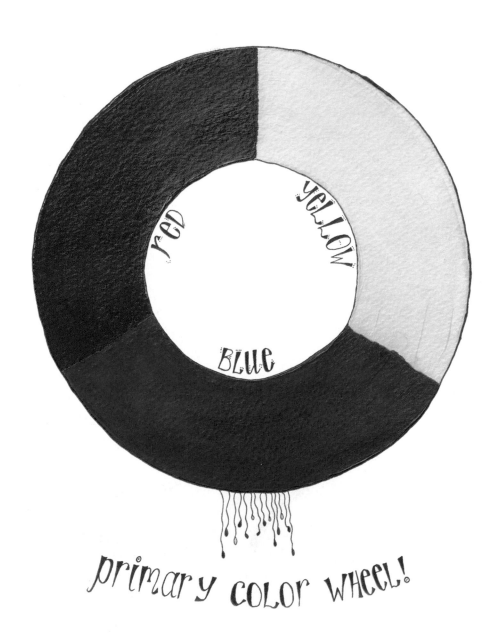

primary color wheel!

acrylic paint, Sakura Pigma Micron pen

Visit www.createmixedmedia.com/zentangleuntangled for extras.

Primary Truth · colored pencil

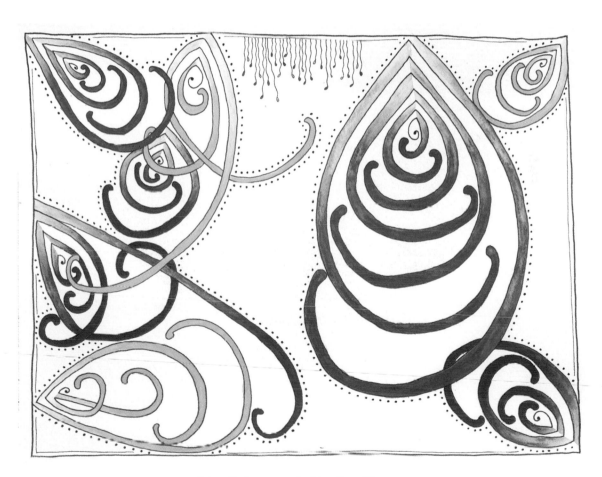

Primarily So · watercolor, Sakura Pigma Micron pen

Sign up for the free newsletter at www.createmixedmedia.com.

55

Secondary colors are made from combinations of the three primary colors. When mixing your own secondary colors, you should start with the lighter color and gradually add the darker color until you get the mix you're happy with.

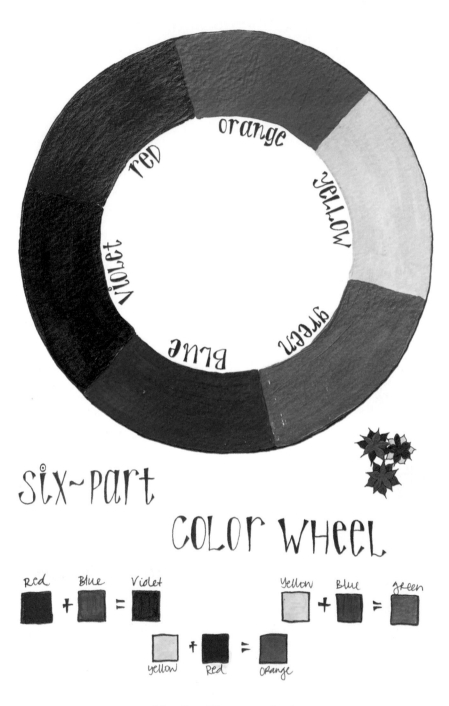

six~part

color wheel

Red + Blue = Violet

Yellow + Blue = green

Yellow + Red = orange

Sakura Pigma Micron pen, acrylic paint

Tennis Anyone? • Sakura Micron pen, Faber-Castell Watercolor pencils

The Australian Open tennis is in Melbourne every January and I rarely miss it. There is something about the international atmosphere, elite sport, and hot summer days that I look forward to year after year. I also sit up through the night for the other Grand Slam tournaments—so no prizes for guessing the origins of this tangle!

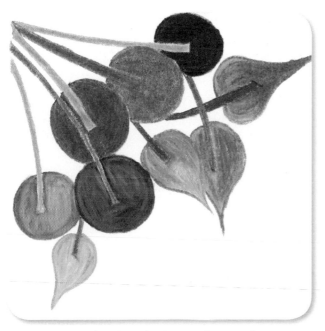

Secondary Growth • Derwent Inktense pencil

Secondary Growth uses different tints of the three secondary colors, orange, violet and green. When you are looking for a color combination that you know works, remember to check out your color wheel. The two colors directly opposite each other (complementary colors) are always the strongest combination available. In the case of *Secondary Growth*, the three colors are equally opposite from each other on the wheel.

Now let's look at how we use color combinations in our Zentangle art.

→

Sign up for the free newsletter at www.createmixedmedia.com.

57

Here we're going to look at complementary colors. Complementary colors sit either opposite or at equal distances from each other on the color wheel. These colors always work well together, but don't be afraid to experiment with them. Use different shades of the colors with each other. This widens your palette and gives you some room to play. And while complementary colors often work best when used as shown, there are no strict rules. Make your art your own. Be brave!

tip: **When referring to the *shade* of a color, it is when black has been added to it. When referring to the *tint* of a color, it is when white has been added.**

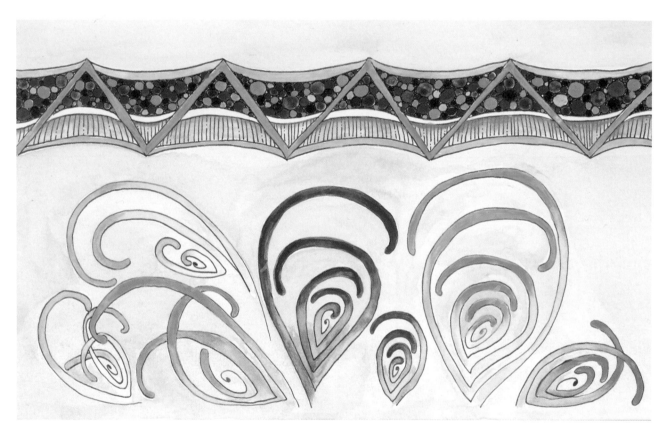

Mooka Complements · Sakura Pigma Micron pen, watercolor

In *Mooka Complements*, I used the secondary colors that complement each other, but with a twist. Instead of a clear orange tint, I chose one with a more yellow tint. I didn't do so intentionally; I just liked the yellow-orange color in my palette and went with it. It worked. The other advantage was that the yellow element of the tint sits equally away from red on the color wheel—and pink is a whitened tint of red. So introducing pink into the work brought a different dimension to the piece, and it came together beautifully. I've followed a similar path in *Fun* on the opposite page.

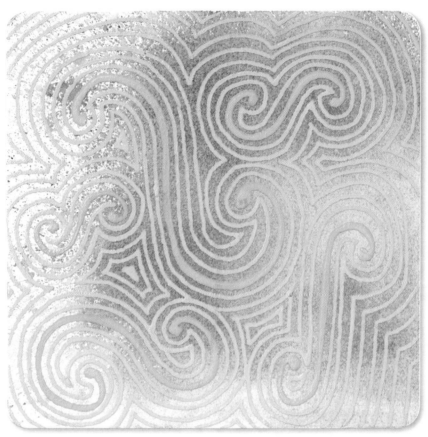

S-Bend · Tim Holtz Distress Stain, Sakura Souffle pens

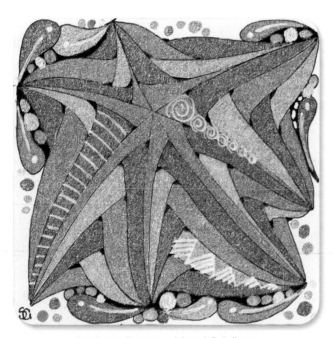

Ice Cream Dreams · Sakura Gelly Roll pens

By Sue Clark, CZT

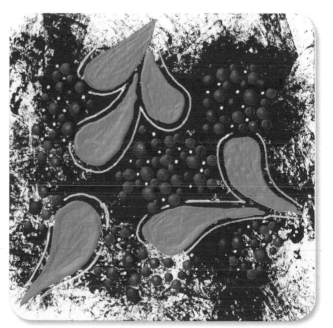

Fun · acrylic paint

Sign up for the free newsletter at www.createmixedmedia.com.

59

Analogous schemes are colors that sit next to each other on the color wheel. Usually three colors are chosen—for example, blue, violet and red (primaries and the secondary between them), yellow, yellow-green and green (the primary, tertiary and secondary that sit next to each other). However, you can expand this as much or as little as you like.

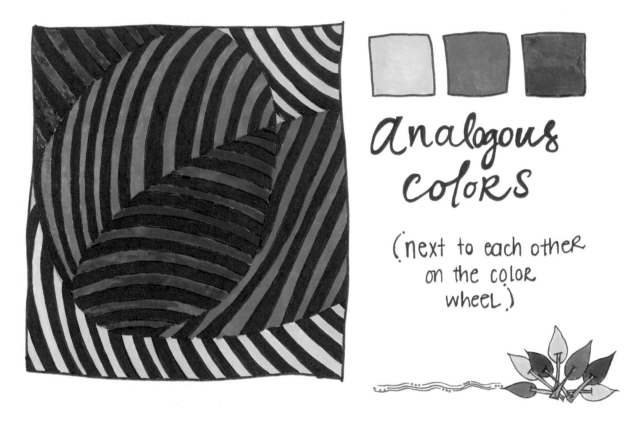

analogous colors

(next to each other on the color wheel.)

Analogous Glaze · Sakura Pigma Micron pen, Sakura Glaze pens

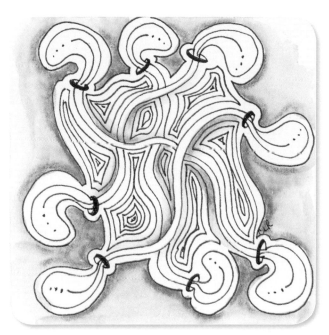

Warm Analogous · Sakura Pigma Micron pen, watercolor/pastel

Chari-Lynn Reithmeier, CZT

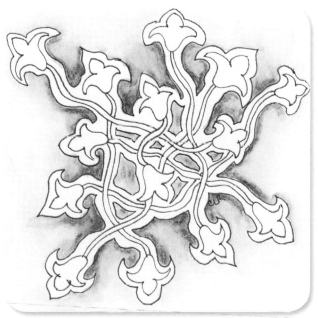

Cool Analogous · Sakura Pigma Micron pen, watercolor/pastel

Chari Lynn Reithmeier, CZT

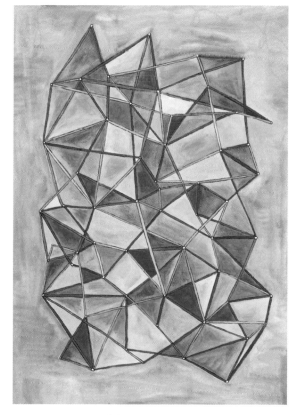

Tink · Watercolor pans

Tink was a lot of fun to create. Although it uses a cooler color palette, there is something outdoorsy and water-like about how this finished up—like a garden by the sea. *Tink* is a tangle created by Carole Ohl, CZT, and I've varied it. I also (inadvertently) used colors that reflect that other *Tink*, a certain fairy in *Peter Pan!*

Sign up for the free newsletter at www.createmixedmedia.com.

61

The third color combination theory I want to share is monochromatic color. This theory uses a single color in various tints and shades. Monochromatic color schemes lend themselves well to Zentangle, as you're about to see.

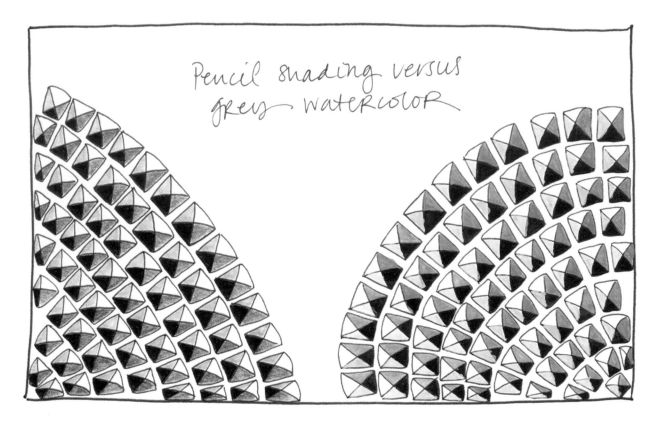

Pencil shading versus grey watercolor

Pinch · Sakura Pigma Micron pen, graphite pencil, watercolor paint

As we've learned, the basic concept of Zentangle® uses the Sakura Pigma Micron pen and shading with a graphite pencil. As we saw earlier, shading really does bring a Zentangle artwork to life and, with the various grades of pencil available, it is possible to get a full range of fascinating effects and color. Another way to achieve similar results is to use various gray markers and watercolor paint.

In this example, I've used a tangle named *Pinch* that has been shaded with various grades of graphite on the left and varying gray watercolors on the right. Although not wildly different, it does bring a different look to the tangle and is a great example of how you can vary the materials you use to create a particular color scheme.

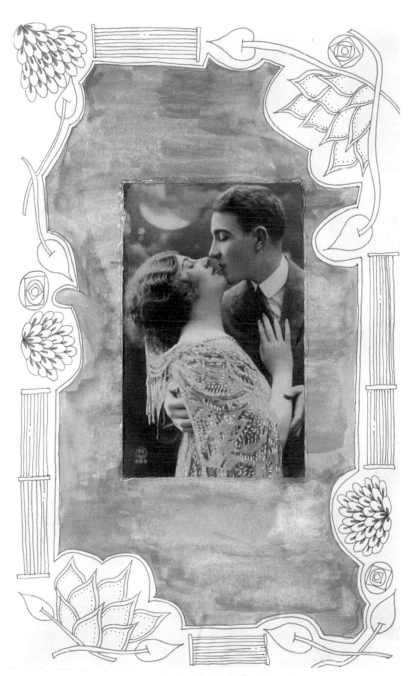

Romance • Sakura Pigma Micron pen, watercolor, collage image by Teesha Moore

Lava • colored pencil, Sakura Pigma Micron pen

If you are incorporating collage elements or mixed-media, look at what colors are in those and use the same color around it. In *Romance* there is a cyan (blue) tint in the photo, so I chose to create a Zentangle border using a blue Sakura Pigma Micron pen and filled it in with blue watercolor paint. This consistency really draws the eye to the couple in the picture—a picture of romance.

Sign up for the free newsletter at www.createmixedmedia.com.

63

CHAPTER 4 · *Art Materials*

Art-Material Intervention

Hello Piet (detail) • gouache, Sakura Pigma Micron pen

When it came to naming this chapter, I wasn't sure how to describe what word summed up all the art materials I would introduce. I sat looking at all my supplies and I realized: I am in need of an art-material intervention.

Some people buy shoes, illicit drugs, fast cars. For me, it's all about art materials. I LOVE art materials. I have some favorite stores to buy from here in Australia, and on various trips to New York, I've spent enough money at a

well-known art store that could rescue the European economy! It's a serious addiction. I love trying different brands, new products and technologies, the latest and greatest.

Does that mean they're all suited to Zentangle? Well...not so much. But I've collected a bunch that do apply well, and I encourage you to try things out for yourself. Playing with art supplies is one of the fun parts of being an artist.

Here's a tip, though: Use what you have. Think about ways you can manipulate materials, collage elements, ephemera. Try materials together. Add layers. See what your artistic spirit brings out. But use what you have before spending big money on more; you'll purchase more wisely if you do so. (I know, it's hard not to lose it in the art supply shop with all the goodness around you, but try!)

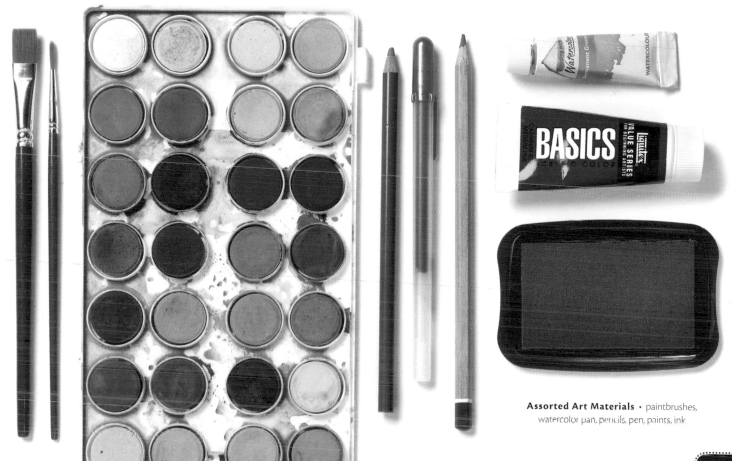

Assorted Art Materials · paintbrushes, watercolor pan, pencils, pen, paints, ink

Sakura is a Japanese pen-making company that supplies the pens in Zentangle kits. The Japanese make incredible quality pens, but until I bought my kit, I'd never used Sakura pens. These days, they are almost the *only* pens I use in my art because they are just so good. I've tried almost every pen I could get my hands on, and nothing beats the quality of Sakura (and I most definitely am *not* being paid to say that!).

Pigma Micron Pens

The first exploration of drawing materials is the colored Pigma Micron pens by Sakura. These fantastic pens come in a range of colors and widths and, with the experience you already have using the black version in your Zentangle kit, you know how beautifully they flow.

On watercolor and printmaking paper, they are bleed-proof, and once dry, they are waterproof, too, so they combine well with inks and watercolor paints.

When I am purchasing art supplies in-store or online, I almost always buy a few extra Pigma Micron pens. Although they last a long time if looked after and stored laying down, I feel like I can never have too many.

See, I wasn't joking when I said I needed an intervention!

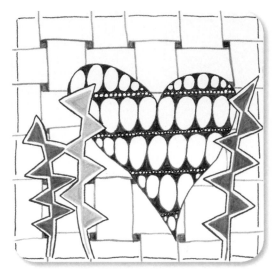

Micron Pen Tester

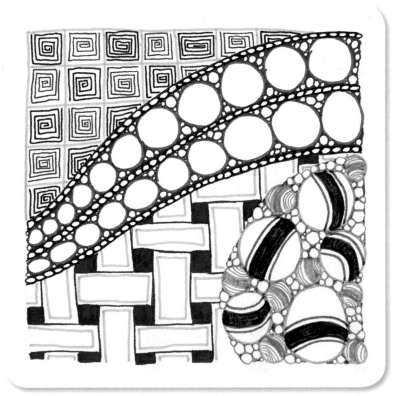

Namby Pamby

Bathroom Wall

Souffle Pens

Souffle pens are dimensional, opaque pens that are pastel in hue and look great on black paper and white alike (as you can see in *Whirly Swirly*). They need about fifteen minutes to dry completely, so they are not as handy on-the-go, but they are lots of fun and are a simple and effective way to bring color and dimension to your tangled art.

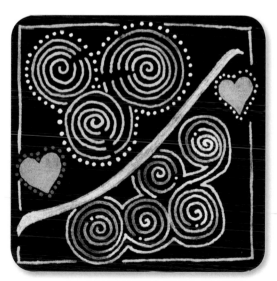

Whirly Swirly

Glaze Pens

If pastel, muted tones are not your style, maybe the Sakura Glaze pens will be. Like the Souffle, the Glaze pens are dimensional pens in bright, semi-transparent colors. They look fabulous—almost good enough to eat. These, too, need some drying time, but they look fantastic when used to draw or color your tangles.

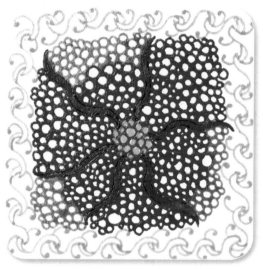

How Does Your Garden Grow

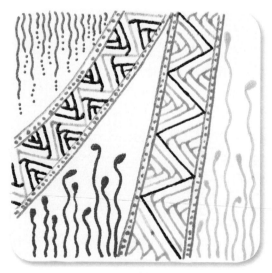

For Sities

Sign up for the free newsletter at www.createmixedmedia.com.

67

Colored pencils are about the easiest art material to get hold of, and they don't have to be expensive. Many brands have excellent student-and kids-quality colored pencils that are sufficient to get started. Wait until you know you'll use them before investing in an expensive set.

Colored pencil are a fantastic way to add color to your Zentangle art; because they can be sharpened to a fine point, they're also great for detail. Each of the big brands have their pros and cons: Prismacolor pencils blend superbly, but I find the leads break easily if I apply any pressure. Faber-Castell are beautiful but expensive. Derwent are also very good but can sometimes be a little too waxy. It's all about personal preferences. Play with each (all can be purchased singularly) and get a feel for what works best for you. You really only need a small set (maybe twenty-four) to get started.

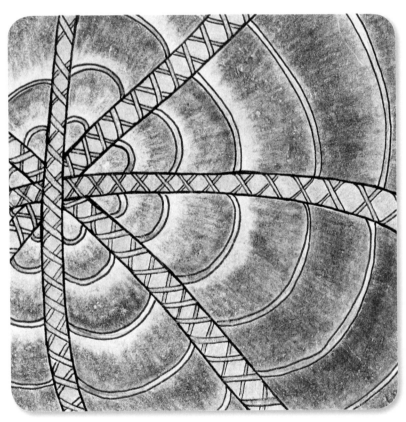

Pink Abyss · Prismacolor Verithin pencils, Sakura Pigma Micron pens

The effect in *Pink Abyss* was achieved by using the Colorless Blender from Prismacolor. It works best with Prismacolor pencils but works with others, too (especially Derwent Coloursoft). These pencils are essential items in my pencil case!

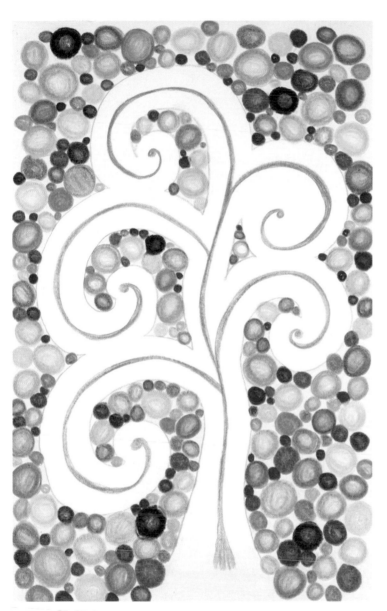

Party · Prismacolor Verithin pencils

Opus is a Zentangle pattern that I created using only pencil. The colors create the shape instead of the pen outline. I used a combination of brands so I could get the widest variety of color hues.

Opus · Prismacolor Verithin pencils, Derwent Coloursoft pencils

Sign up for the free newsletter at www.createmixedmedia.com.

69

Inktense Pencils

I remember a few years ago seeing an ad for Inktense pencils in a magazine. They looked sublime but were not yet available in Australia. So I ordered the 72-color tin online—a huge gamble, but one that paid off beautifully. They are every bit as awesome as I'd hoped, and I think the best product in the Derwent range. When dry, they become waterproof and lose none of their pigmentation.

The vibrancy of the colors and their versatility—you can use them wet or dry—make them a must-have.

Derwent has released Inktense blocks—sticks shaped and used like hard pastels, but still water-soluble. They bring a new use to Inktense, especially in covering larger areas. My art-materials addiction has been further assisted by these beauties!

Having that variety of applications makes Inktense a fantastic companion to Zentangle. The combination of the waterproof Sakura pens and the vibrant Derwent colors is a treat; the colors can be as bright or subtle as you want to make them. The thicker the color application, the more opaque it becomes. Play with your Inktense pencils; do some test pages of half-wet, half-dry color to get a true sense of what these pencils are capable of producing.

Kindy Cadent · Inktense pencils

Goodie Box · Inktense pencils, Sakura Pigma Micron pen

Crescent Moon · Inktense pencils

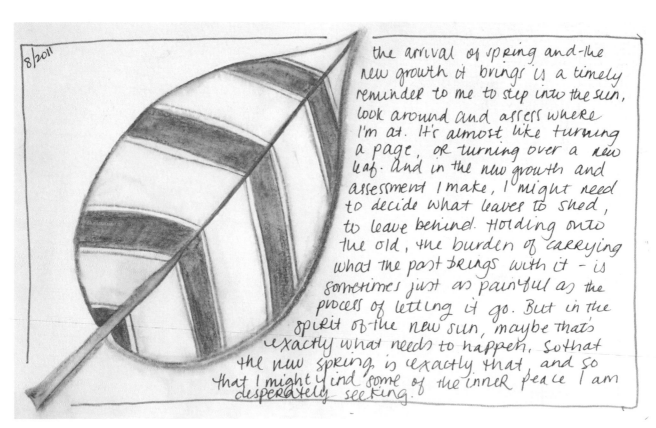

8/2011

the arrival of spring and the new growth it brings is a timely reminder to me to step into the sun, look around and assess where I'm at. It's almost like turning a page, or turning over a new leaf. And in the new growth and assessment I make, I might need to decide what leaves to shed, to leave behind. Holding onto the old, the burden of carrying what the past brings with it - is sometimes just as painful as the process of letting it go. But in the spirit of the new sun, maybe that's exactly what needs to happen. So that the new spring is exactly that, and so that I might find some of the inner peace I am desperately seeking.

New Leaf · Inktense pencils, Sakura Pigma Micron pen

Sign up for the free newsletter at www.createmixedmedia.com.

71

Ahh, ink—a material for the ages and one of the loveliest to use still. There is a reason it has lasted through the centuries.

The beauty of time and technology means that inks have developed in opacity, lightfastness and quality. This is great news for tangle enthusiasts (many have high-quality skills with ink because they have a calligraphy background), and the relationship between the two art forms is clear.

In these pieces, I've used a variety of inks. Look for high-quality, pigmented inks to use; the color will be more consistent and vibrant. Use a watercolor brush, high-quality pens (try using calligraphy nibs for drawing lines) or a waterbrush filled with ink. Be sure that when you're using pens with your liquid inks, they have waterproof ink (like the Sakura Pigma Microns or Copic Multiliners), or things will get messy fast!

Another type of ink many crafters will know is the Tim Holtz Distress Ink line by Ranger Industries. Tim has a range of Distress Ink pads and now stains. You can use these in a variety of ways. I often use them as the bottom layer of color, and they give a beautiful background, foundation and dimension for gorgeous Zentangle art.

Ocean Gold · Tim Holtz Distress Ink, Liquitex acrylic ink, Winsor & Newton ink, Sakura Pigma Micron pen

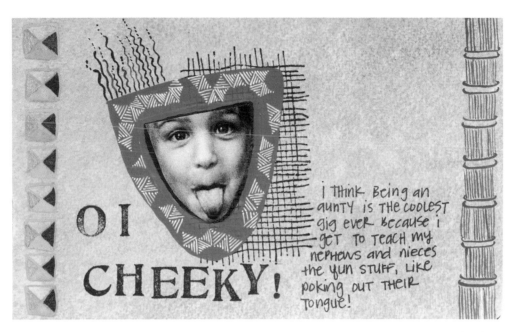

Oi Cheeky · Sakura Pigma Micron pen, Liquitex acrylic ink, StazOn ink pad, Winsor & Newton ink, Teesha Moore journalling element

Nouveau · Tim Holtz Distress Ink, Sakura Pigma Micron pen

Sign up for the free newsletter at www.createmixedmedia.com.

73

I started using watercolor pencils one Christmas while staying with my in-laws. They have a beautiful garden, and I decided to pass some time by drawing the flowers they grow using some basic watercolor pencils I had picked up at a local art store. It's a fabulous way to add color and, like Inktense, watercolor pencils can be used wet and dry.

Watercolor pencils are more transparent than Inktense—more like watercolor paints (obviously!)—but you can build up color with them and achieve more vibrancy. Experimentation will bring a good working knowledge of these brilliant pencils.

I usually wouldn't recommend one product over another, but in the case of watercolor pencils, I cannot go past the Faber-Castell Albrecht Durer range. They are flawless, strong and peerless. They're not the cheapest, but they are absolutely worth every cent (and can be bought individually if you want to build a collection over time).

Waffle Cone · Faber-Castell Albrecht Durer watercolour pencils

Blue Lagoon · Faber-Castell Albrecht Durer watercolour pencils

At One With Nature · Faber-Castell Albrecht Durer watercolor pencils, Sakura Pigma Micron pen

Sign up for the free newsletter at www.createmixedmedia.com.

75

Over the years I think I have tried every art medium known to mankind. Acrylics were a long-time favorite, but as I started to become more mobile, I needed something more flexible. On chance a few years ago, I bought a set of watercolor pans at an art store in New York. They have changed my life. They are easy to carry and provide vibrant color. The ones I bought were less than twenty dollars for a set of thirty-six colors, student-grade pans. I've since invested in expensive, artist-grade pans and, if you can keep a secret, I much prefer my cheap ones! They are wonderful proof that you do not need to spend a lot of money to get great results.

The big advantage of watercolors with Zentangle is their ability to cover large areas or provide minute details. The Sakura Pigma Micron pens are waterproof, so you can either put pen to paper first and then add watercolor, or put your color down first and then add pen (make sure your paint is completely dry first to avoid pen-bleed).

Many people love watercolor paint in tubes and enjoy mixing the water themselves. Tube colors can often be more pigmented and brighter, but they don't provide the flexibility of pans, particularly if you are on the road. Whatever suits you is great—there are no rules!

Who Sez? · watercolor pan paint

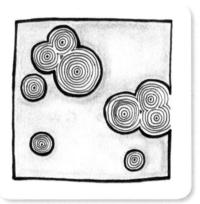

Sez · Sakura Pigma Micron pen, graphite pencil

The tangle *Sez* appealed to me at first sight. Its retro look is so much fun.

I decided to paint this tangle without the pen, using the various colors instead to create the rings. This approach is an effective alternative to drawing the tangles first and brings a new method to your Zentangle art.

Part of the retro fun of *Sez* is when color is added. The concept of *Sez* is quite simple, but instead of using pen to create lines, I chose to let the color of the paint create the lines. It was painstaking work to create (I used analogous colors violet, red and blue in various shades) and then I created the "linking circles" in orange (which continued the analogous theme). Playing with color can be an effective and simple way to create a point of difference without actually doing something differently than first taught.

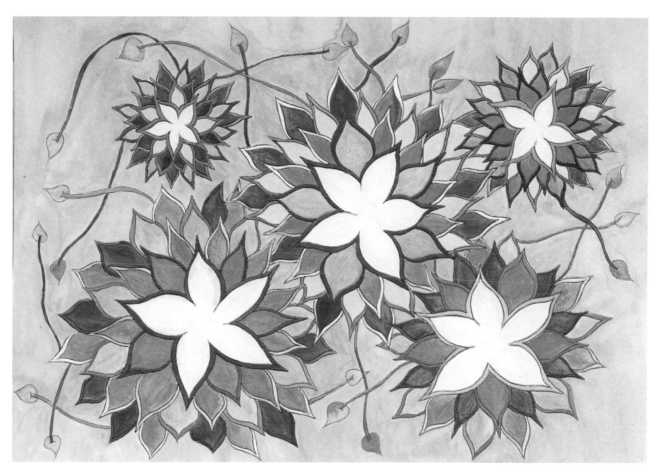

The Summer Garden · watercolor, watercolor paper

Cyme · Sakura Pigma Micron pen

This is possibly my favorite ever Zentangle creation. It uses the official tangle *Cyme* and a tanglation of the pattern *Pokeleaf*.

Cyme is a "go-to" tangle for me. It pops up in my Zentangle and art journaling work regularly. It is an organic, flower-based tangle. When I created *The Summer Garden*, I started with several smaller flowers at various places on the page and then gradually built them out until they connected. This wasn't deliberate—I just let the pen take me where it needed to go. Once the pen work was finished, I chose my color palette and tried to mix it up as much as possible. I then added the leaf tanglation of *Pokeleaf*. Finally, I felt that the whole page needed a background color and the blue was a perfect complement to the summer, citrus palette of the flowers.

I started with the center petals on all five blooms, and then I gradually built them up until they met. As they met, I used the "drawing behind" method so they appeared to layer over each other. I then chose various shades of pink, red, orange and yellow for the petals on a blue background. The blue watercolor is not consistent, but that is what I love best—the various water levels add organic markings, giving some dimension and character.

Sign up for the free newsletter at www.createmixedmedia.com.

77

Gouache is a type of watercolor paint that was traditionally used by graphic designers before the arrival of computer design technology. It is an opaque paint that is activated by water and dries to a matte finish. Many designers still use gouache, as do illustrators, but it does takes some practice. Gouache looks fantastic on printmaking and watercolor papers.

Take a squirt of gouache from your tube and add water. I do this one drop at a time because if it becomes too watered-down, gouache becomes more transparent. It is important that you mix enough and use your paint in one sitting; it will stay wet in the palette for a few hours but will eventually dry out. However, once you get the hang of using gouache, it has the potential to become a favorite medium.

Gouache can be used as a large coverage paint, as well as providing detailed work. This makes gouache a beautiful companion to Zentangle.

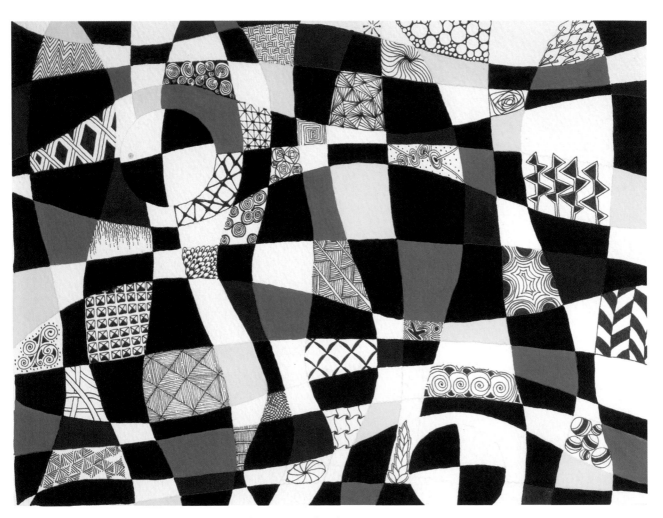

Hello Piet · gouache, Sakura Pigma Micron pen

Gizmo · gouache

Evoking Peace · gouache

Sign up for the free newsletter at www.createmixedmedia.com.

79

The final medium I want to introduce you to is acrylic paint. I'm sure acrylic needs little explanation because most of us have used it since preschool. Acrylic is a versatile medium that can cover large areas as well as provide detail. It is quick drying and comes in every color you can imagine. Acrylic is a great way to add color to your Zentangle art.

My tip with acrylic is to use a fluid acrylic; heavier-bodied acrylics can become arduous quickly with Zentangle, especially if you are working on a small scale or are looking for fine details. Golden Fluid Acrylics are artist-grade paints that work well, but also look for craft acrylics like Claudine Hellmuth's Studio line, especially in the small squeeze bottles. These allow you to control your output. I use both types, and there are many great brands out there for you to try.

Remember from our look at color theory, that when mixing paints, start with the lighter color and slowly add the darker one to get just the right mix!

America The Beautiful · acrylic paint

Chelsea Manhole · acrylic paint, glimmer mist

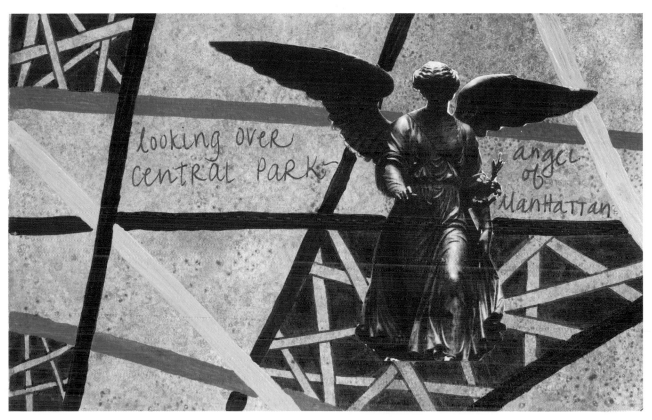

Angel of Manhattan · acrylic paint, Sakura Pigma Micron pen, photograph

Sign up for the free newsletter at www.createmixedmedia.com.

81

CHAPTER 5 · *Art Journal*

Art Journalism

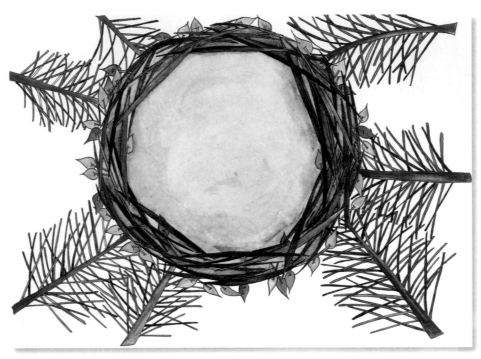

Nest · Sakura Pigma Micron pen, watercolor pans

If the explosion of blogs and books about art journals and sketchbooks is any indication, interest in journals is reaching new and dizzying heights. There is a lot of advice out there, and what I offer here is not definitive. It's just what works for me.

Spending time reading books like this and various blogs can be very useful. You'll see what others do, sometimes pick up tips and techniques, and get ideas about what sort of journal you'd like to keep.

The overload of information can also intimidate the beginner journalist—and even those, like me, who have kept art journals for several years now! The amount of talent on display is phenomenal, but you, too, have something to offer.

I'm often asked if there is a difference between an "art journal" and a "sketchbook." In my mind there is some difference, but essentially it doesn't matter if you call it an art journal, sketchbook, visual diary or Barry (has anyone actually named their journal that?). It is simply a place for you to test, try, stick, paint, write, draw and play.

For the purposes of this book, let's go with art journal.

There are so many amazing art journalists whose talents vary across many media. Teesha Moore's whimsical, playful journals are chock-full of color and collage. Linda Woods and Karen Dinino's books also utilize color and collage but incorporate everyday items and photography into their journals. Then there's the incredible Danny Gregory, who largely uses pen, ink and watercolor when documenting his life in his journals. He draws what he sees in ways I can only aspire to. All three approaches to this art form are legitimate, and all fall into the category of art journal.

I started as an art journalist from my scrapbooking history. My first journals very much lent themselves to what I would call a scrapbook style. When I began my art degree in 2006, I started to keep a visual diary as part of my studies. My art journals began to take more of a sketchbook approach, and that is largely how they remain, although I do still incorporate a lot of my photography into my sketchbooks. I learn so much through photography, and it is no less a documentation process than any other approach.

Is there any right or wrong way to begin? No! I would, though, encourage you to begin simply.

MY SUGGESTED BEGINNER'S KIT WOULD INCLUDE:

- 2–3 graphite pencils (maybe a HB, 2B and 6B to begin with)

- 2–3 artist pens (Sakura, Copic and Faber-Castell are all in my collection) of different nib sizes (.01 and .05 are a great place to start)

- A small set of colored pencils or a small watercolor travel kit

- A small glue stick, in case you find something that you need to stick in

- A journal! For portability, I'd suggest a 5.5" × 8" (14cm × 20cm) Strathmore

- Wirebound Visual Journal or a Moleskine Watercolor Journal. If you plan to use watercolors or any wet media, I would ensure the paper is at least 90lb (190gsm), so it doesn't buckle too much—unless you like that!

So you've got some fun art materials, a journal and twelve tangle patterns (plus any others you can find in books and online). You're all set to take your Zentangle to a new level!

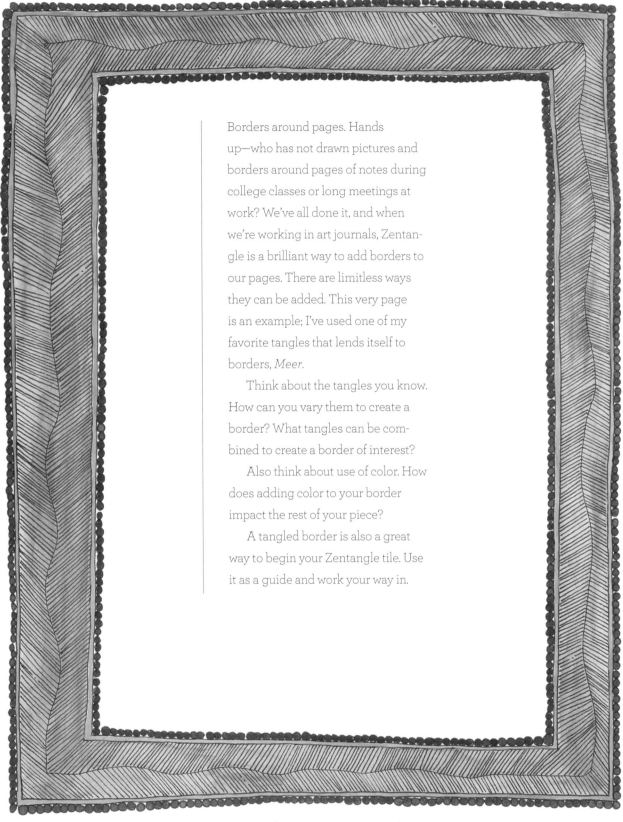

Borders around pages. Hands up—who has not drawn pictures and borders around pages of notes during college classes or long meetings at work? We've all done it, and when we're working in art journals, Zentangle is a brilliant way to add borders to our pages. There are limitless ways they can be added. This very page is an example; I've used one of my favorite tangles that lends itself to borders, *Meer*.

Think about the tangles you know. How can you vary them to create a border? What tangles can be combined to create a border of interest?

Also think about use of color. How does adding color to your border impact the rest of your piece?

A tangled border is also a great way to begin your Zentangle tile. Use it as a guide and work your way in.

Party • Sakura Pigma Micron pen, watercolor

Party · Sakura Pigma Micron pen, watercolor

Red Spot · black Zentangle tile, white gel pen, red Stickles glitter glue

Surprise · Sakura Pigma Micron pen

Sign up for the free newsletter at www.createmixedmedia.com.

85

So the other thing I think we all have to own up to (besides drawing borders around those meeting notes) is practicing our fonts and lettering in the margins. I'm not wrong here, am I? I am definitely a type geek, and I love looking at hand-drawn fonts (check out illustrator Mike Perry's work for some inspiring hand-drawn fonts) and practicing my own.

Zentangle and fonts are numerous, but I wanted to share a few ideas on these pages. First, my favorite quote from Khalil Gibran with different tangles inside the letters. Then a more traditional approach with gold ink and an old-fashioned font. And a colored pencil interpretation of the Robert Indiana *LOVE* print.

The link between Zentangle and lettering is strong. Many calligraphers are using Zentangle in their artwork, and Zentangle was devised by the master calligrapher herself, Maria Thomas. Look at image-storing websites like Flickr; some of the work will blow your mind.

Gold K · Sakura Pigma Micron pen, gold ink

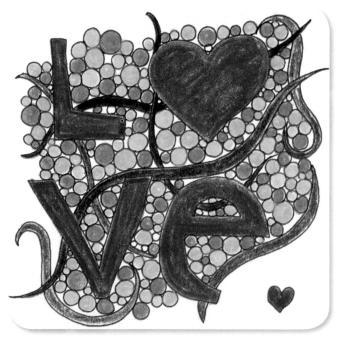

Love · Sakura Pigma Micron pen, colored pencil

Kass · Sakura Pigma Micron pen, graphite pencil

by Sue Clark, CZT

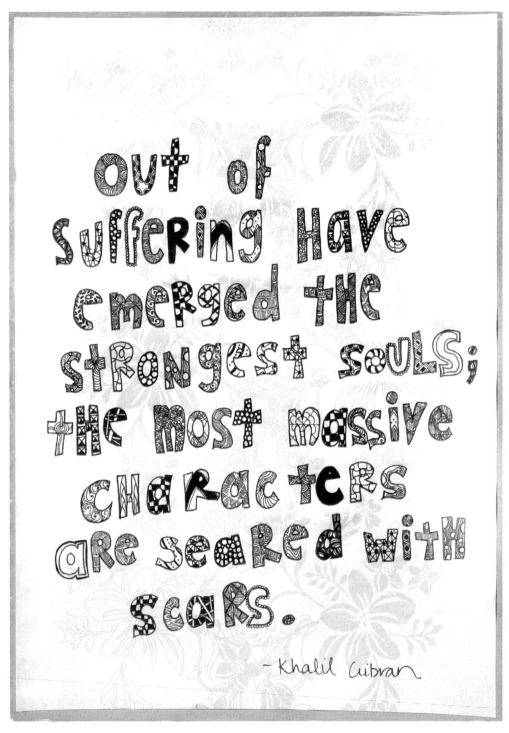

Gibran Quote · patterned paper, acrylic paint, Sakura Pigma Micron pen

Sign up for the free newsletter at www.createmixedmedia.com.

87

When it comes to using Zentangle in your art journals, using tangles as backgrounds for your mixed-media is a brilliant and unique look. It is also very adaptable. It might seem like a lot of work to do an entire background in Zentangle, but I've shown here three effective ways to do so, each being completely different in the length of time required and complexity.

The most complex background is that in *Amelia*. The original photo has my baby niece (isn't she lovely?) laying on a quilted blanket. I decided t to create a background representing the blanket using Zentangle. It took some time to create and then color using watercolor pans. I remember showing this to my sister, and she loved the way I was able to create the background.

The *Library* background is a large-scale tangle called *Bales*. I didn't know where this work was headed when I started, but as I colored the background, it reminded me of wallpaper from the 1970s. Something about it said "library" to me, and people have always said I should have been a librarian—my love of books rivals only my love of art supplies. It works, doesn't it?

The final work, *Imaginaria*, began randomly as I sat at the hospital waiting for a scan. I needed something to divert my mind, and I had my Moleskine journal with me. So I started drawing and used some Zentangle concepts, varied them and waited to see what happened. I'd put some collage elements in my folder to jog my creativity (let's face it, hospitals don't inspire creative genius), and this was the result. It was a simple piece, easy to work on while on the road, and yet the background brings something whimsical to the piece.

Imaginaria · Sakura Pigma Micron pen, watercolor, collage piece by Teesha Moore

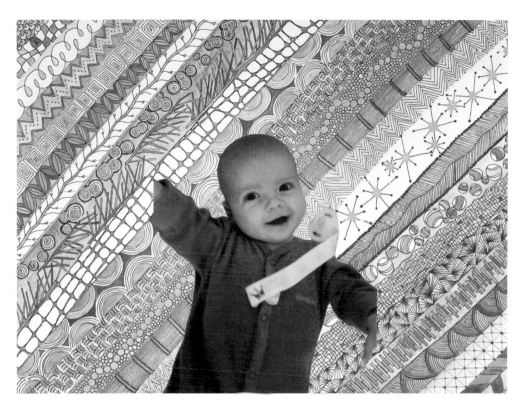

Amelia · Sakura Pigma Micron pen, watercolor, photograph

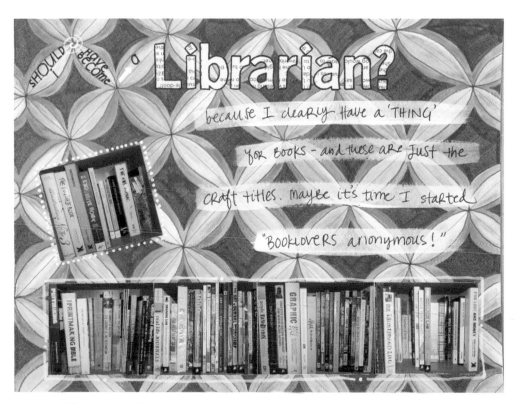

Library · Sakura Pigma Micron pen, watercolor, patterned paper, gesso, photographs, Posca Paint pen

Sign up for the free newsletter at www.createmixedmedia.com.

89

Patterned paper can be a huge inspiration for Zentangle enthusiasts. The stationery trade shows, scrapbooking papers, writing notes...there is so much paper goodness around, and so many of them can be included in your Zentangle-inspired artwork! You'll notice as you go on your Zentangle path that patterns become very noticeable—in nature, in branding, everywhere you look. Life won't be the same again, I promise!

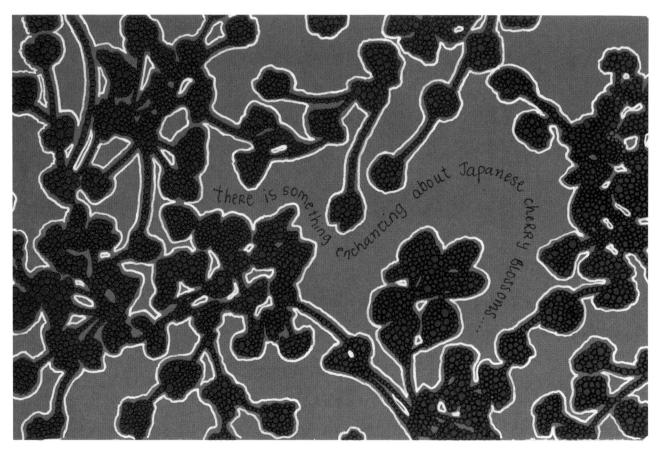

Cherry Blossom · patterned paper, white gel pen, Sakura Pigma Micron pen

Cherry Blossom started life as a scrapbook paper I've had sitting in my paper stash. It already had the red blossoms, so I used *Quipple* to add detail to it.

This simple tangle and the white outlines change the look of the original paper and make a great start to a journal page or a standalone artwork.

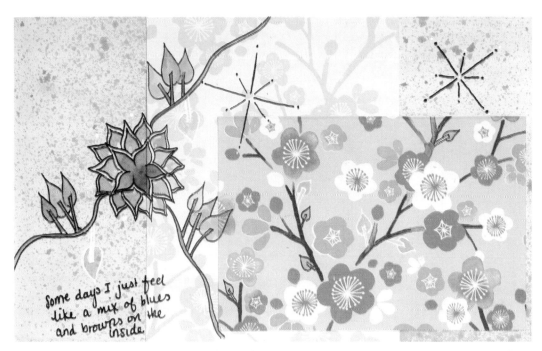

Blue and Brown Days · patterned paper, Sakura Pigma Micron pen, watercolor, Tim Holtz Distress Stain

A combination of patterned papers and tangle patterns worked effectively to create the overall feel of the art journal page in *Blue and Brown Days*.

Three tangles (*Cyme*, *Pokeleaf* and *Aah*) were used together to give some continuity to the page design.

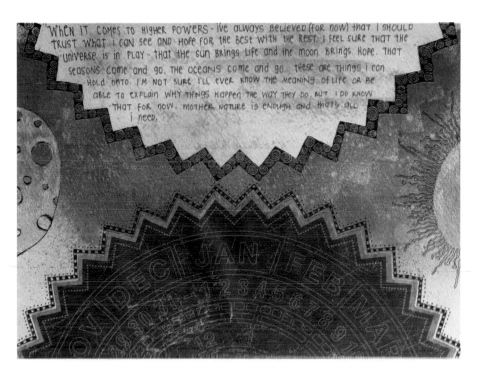

The Universe at Play · Sakura Pigma Micron pen, patterned paper, Tim Holtz Distress Stain, ink

The patterned paper in *The Universe at Play* went a long way to guiding the theme of this artwork. It started with the sundial-shaped paper and used the leftover piece and glimmer mist and inks to get the yellow-orange effects. Creating the sun, moon and outlining elements with Zentangle was a perfect way to bring the theme together.

Sign up for the free newsletter at www.createmixedmedia.com.

91

Page accents are three-dimensional elements that you add to your journal. It might be a plane ticket or a photo, or it might be something you made yourself. There are no limits to what page accents can look like, but they are a great opportunity to bring some Zentangle goodness to your artwork.

Yellow Pair · white and yellow cardstock, Sakura Pigma Micron pen, pencil, foam dots

by Geneviève Crabe, CZT

Zen Flower · red and white cardstock, Sakura Pigma Micron pen, pencil, metallic brad

by Geneviève Crabe, CZT

Geneviève Crabe, CZT, makes gorgeous brooches using Zentangle® patterns, including the *Betweed Pin* shown. There's no reason these can't be used in journals as well. Geneviève also created the cards opposite, creating shapes using Zentangle and applying them to the cards. These unique and interesting cards are great to give and receive. I especially love the way Geneviève has used several tangles in one element to create interest.

Betweed Pin · Wooden flower shape, acrylic paint, Sakura Pigma Micron pen, crystal, pin-back

by Geneviève Crabe, CZT

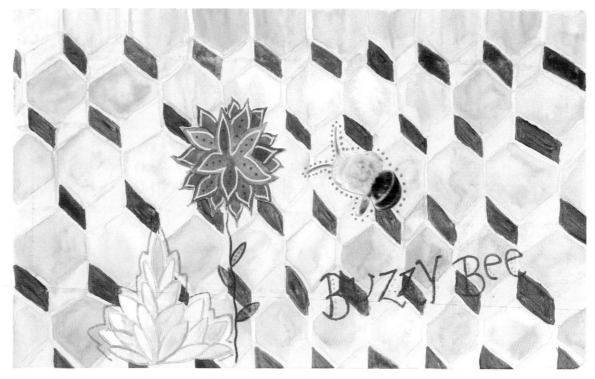

Buzzy Bee · Watercolor, paper, glitter pen, photograph, gel pen

Sign up for the free newsletter at www.createmixedmedia.com.

93

Rubber stamping and art journals have a long relationship, and stamps are a great way to add imagery to your art journals. One of the fun parts about creating this book was looking for stamps that would suit Zentangle. I ended up with more options than I could use! Stamps provide great shape and inspiration for Zentangle-inspired art.

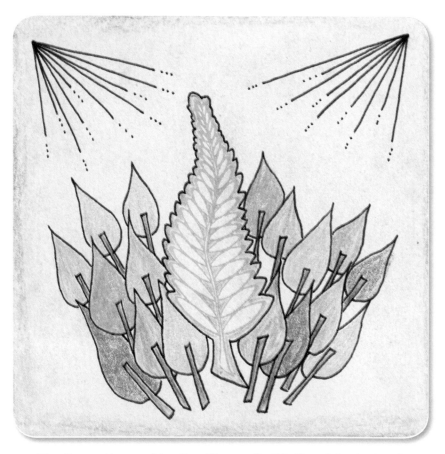

Silver Fern · rubber stamp, Sakura Pigma Micron pen, Tim Holtz Distress Stain, colored pencil

Oh Canada! · Tim Holtz Distress Stain,
Sakura Pigma Micron pen, StazOn Ink pad, rubber stamp

Payne's Grey Monochrome · ink, rubber stamp,
Sakura Pigma Micron pen

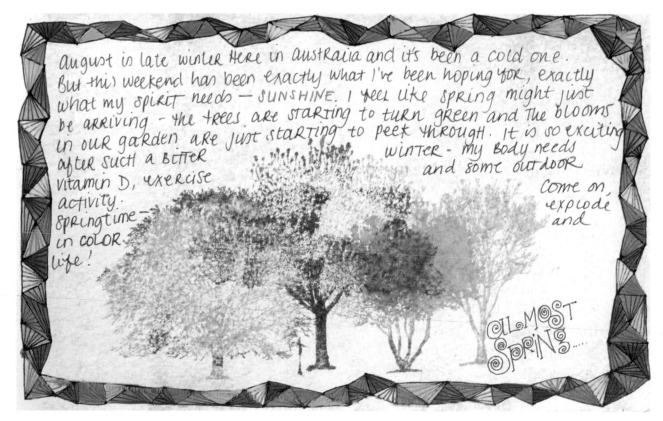

August is late winter Here in Australia and it's been a cold one. But this weekend has been exactly what I've been hoping for, exactly what my spirit needs — SUNSHINE. I feel like spring might just be arriving — the trees are starting to turn green and The blooms in our garden are just starting to peek through. It is so exciting after such a bitter winter — my body needs vitamin D, exercise and some outdoor activity. Come on, explode and springtime — in COLOR. life! ALMOST SPRING....

Almost Spring · Tim Holtz Distress Stain, watercolor, rubber stamps (*Darkroom Door* by Rachel Greig), Sakura Pigma Micron pen

Sign up for the free newsletter at www.createmixedmedia.com.

95

Zentangle brings so much to artwork, in particular an ability to use pattern to create imagery and shape. So many amazing things can be created.

I asked my fellow CZTs to see what they could come up with using Zentangle® to create shape. Really, there are examples throughout this book if you look.

The piece *Birdy* was created by KathyAnne Whittemore, CZT, and it reflects the peaceful, calm personality of this beautiful lady. When she showed it to me, it struck me that KathyAnne had created not only a beautiful shape and creature with Zentangle, but a soulful artwork. It is an incredible way to utilize the skills Zentangle develops in us.

On the opposite page are two pieces from Beckah Krahula, CZT. Beckah has applied her Zentangle knowledge to create cityscapes—what an incredible way to show off a city! The first is a larger-scale work that Beckah created while visiting Houston. The tile-sized piece, *Union Square San Francisco*, also depicts the scene of a loved space in San Francisco. The heart shape reflects a theme from an exhibition the tile was created for.

What other shapes can be created using tangles? What shapes are found within tangles themselves?

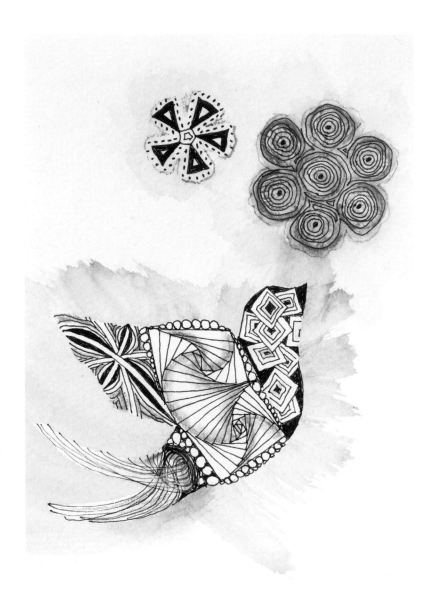

Birdy • Sakura Pigma Micron pen, watercolor, graphite pencil

by KathyAnne Whittemore, CZT

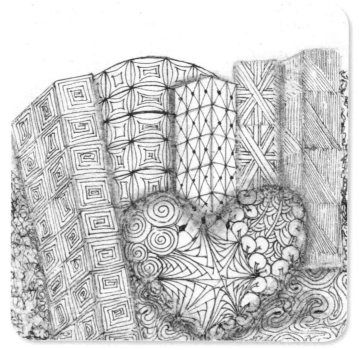

Union Square San Francisco · Sakura Pigma Micron pen, graphite pencil

by Beckah Krahula, CZT

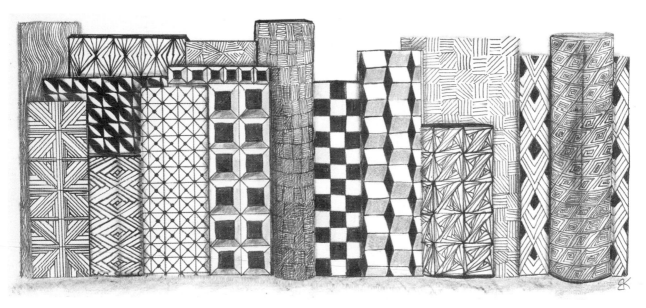

Tangled Houston · Sakura Pigma Micron pen, graphite pencil

by Beckah Krahula, CZT

Sign up for the free newsletter at www.createmixedmedia.com.

97

My passion for photography goes back as far as I remember. My first camera, in primary school, took 120mm film and was bright yellow. Since then I've graduated through several point-and-shoot cameras to digital SLR, as well as the fun of Lomography and Polaroid. I adore how capturing a single moment in time can instantly evoke memories and feelings.

Photography is a great tool for snapping patterns and textures as you're out and about, which inspires Zentangle® in its origins and continuing journey. Zentangle also makes a wonderful companion to photographs in art journals and scrapbooks. I often include photography in my art journals because it provides unlimited inspiration to me. Using Zentangle with photography makes my pages uniquely mine and different from much of what we see in magazines and online.

The three journal pages shown reflect some of my life's passions—my nephew (and godson) Lukas, my pug, Sunny, and an elephant (I sponsor an orphan elephant in Kenya). Many people journal about a range of topics—some whimsical and about nothing in particular. My pages often reflect my life in some way—family and friends, the things that I love. I also love Zentangle, so it's an easy choice to include it with my photographs and journals.

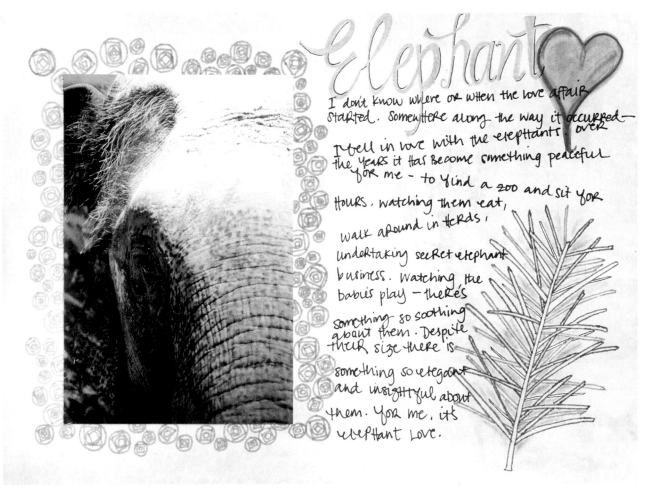

Elephant Love · watercolor, Sakura Pigma Micron pen, ink, Derwent Inktense pencil, photograph

Visit www.createmixedmedia.com/zentangleuntangled for extras.

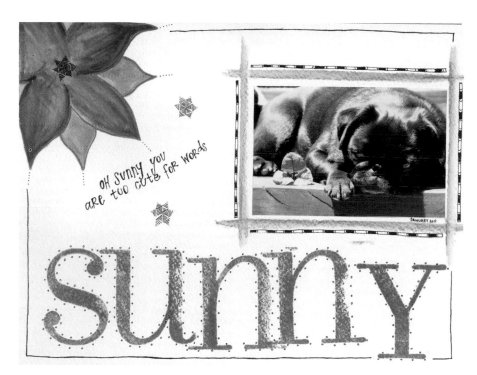

Sunny • watercolor, rubber stamp, Sakura Pigma Micron pen, Tim Holtz Distress Ink pad, foam stamps

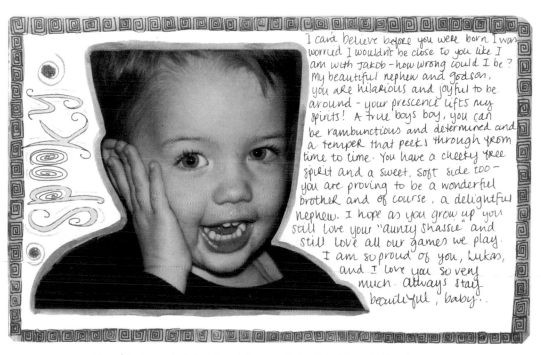

Spooky • watercolor, Sakura Pigma Micron pen, Broken China Distress Stickles, glitter pen

Sign up for the free newsletter at www.createmixedmedia.com.

99

One of the special things about Zentangle® is that it is hand-drawn. No matter what level of artistic talent you possess, you can succeed in this art form. One of the other appealing aspects (for this artist anyway) is that Zentangle can be done anywhere, especially away from the computer screen! I spend way too much time on my Mac, but it's an occupational hazard of being a writer and artist, and working from home!

When I was at University, I studied several graphic design units. I love good graphic design, but I'll confess—it's just not my area of talent. As a student, I bought Adobe® Creative Suite® 3 (thank goodness for student rates) and managed to pass my graphic design units, but I have found that I've actually learned the most by simply playing with the programs. By chance, my local bookstore recommended an all-in-one book they had. It was fantastic advice, and the book is really easy to navigate and understand, making it easier for me to retain what I learn. It has hundreds of sticky flags, highlighter marks and pencil notes in it!

So why not go digital with Zentangle?

I would strongly emphasize that the fun and relaxation goes out of Zentangle if you take the pen and tile out of it. As we've seen, there are so many ways to add color, texture and dimension to our Zentangle-inspired art. What I demonstrate here is just another option.

tip: **When you scan your Zentangle® tiles and backgrounds, scan them at a minimum of 300 dpi. This is especially important if you plan to print your work later.**

All the tangles you see here are hand-drawn. In fact, I deliberately used scans of tangles featured earlier in this book to demonstrate this technique because I want to encourage you to keep that pen-and-tile element as central to what you do; using line tools and shapes, etc., in Adobe® Photoshop® will be a total killjoy!

One of the other fun things about this approach is that if you are creating colorful backgrounds in your art journals, before adding elements like words, photography and accents, you can scan your background and use it in your digital works. That's what I do. I grab loose paper or a journal and create colored backgrounds, slapping paint or ink randomly, using a brayer to spread color, absolutely anything goes. I especially love using canvas paper (available at your local art supplier), which often gives a new and excellent texture—and it comes up a treat when scanned. This, if nowhere else, is where you have full and complete license to experiment, play and get messy.

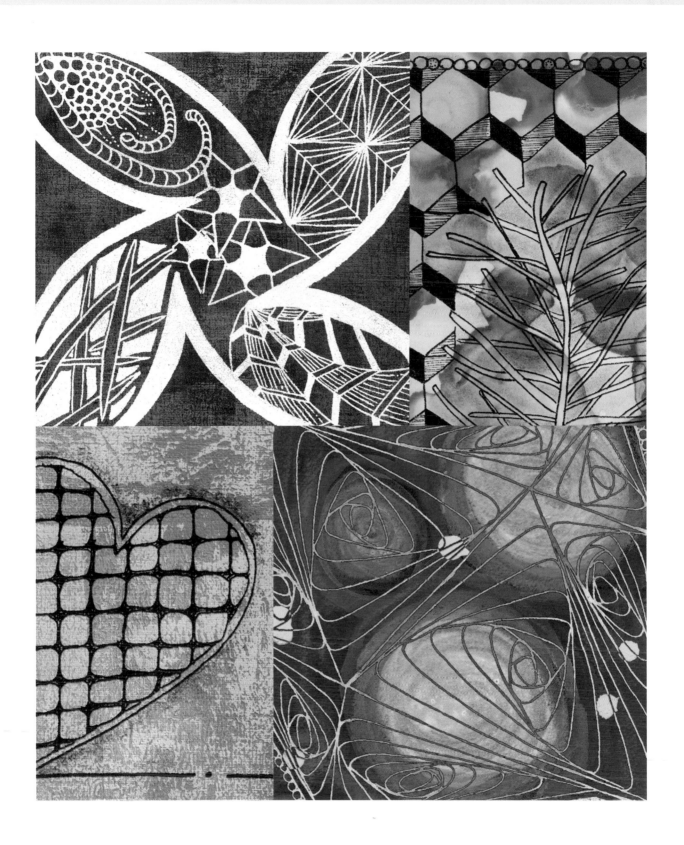

Sign up for the free newsletter at www.createmixedmedia.com.

101

DIGITAL MYSTERIA

find the original black-and-white in The History of Zentangle

Digital Mysteria incorporates the tangle *Mysteria*, drawn on a regular Zentangle tile and scanned, with painted paper that I scanned. I then combine the two to create a whole new piece of work.

materials **Original Zentangle • Adobe® Photoshop®**

1 Open Adobe® Photoshop®.

2 Select the background file you wish to use. *File > Open > select file.*

3 Making sure you have your Layers window open, create a new layer (always make sure your layers have a transparent background).

4 Place your chosen tangle onto the background. *File > Place > choose your tangle.*

tip: **I recommend having a separate folder for your digital files, with sub-folders for your scanned tangles, scanned backgrounds and final works. It will help you keep your brain straight!**

Visit www.createmixedmedia.com/zentangleuntangled for extras.

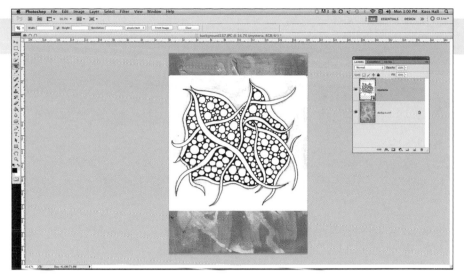

5 Expand the tangle until it is perfectly square at the desired size. It will cover your background at this stage. Hit RETURN to complete the placement. You can still move it if you need to, but placing it will improve the appearance on screen of your scanned tangle.

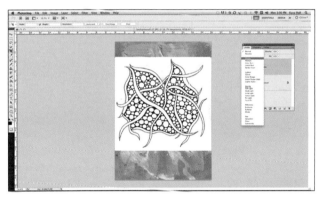

6 Using the drop-down menu in the Layers window, play with the various Layer Blending Mode options. Some will look great, others offer little. In this example, I've used the *Darken* option.

7 Crop your image. I created a square image, but it's up to your artistic discretion.

8 Flatten your layers. *Layers > Flatten Image.*

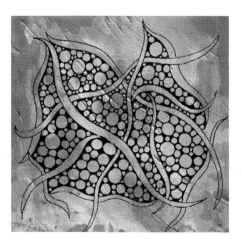

9 Save your file, using the *Save As* function.

Sign up for the free newsletter at www.createmixedmedia.com.

103

Once you get the hang of it, there is no limit to what you can do. Go and play!

One of the really great advantages of digitizing your Zentangle art is the flexibility it can bring to your art journals. Not only can you stick your printed-out digital tangles into your journal, you can use them as collage layers, too. Maybe they can provide the base layer for your journal page?

If you print them out on a laser printer, you can also add some of your existing art supplies over the top, including watercolor and gouache, Stickles or maybe even rubber stamp over them. The potential is endless and only limited by what you're willing to experiment with!

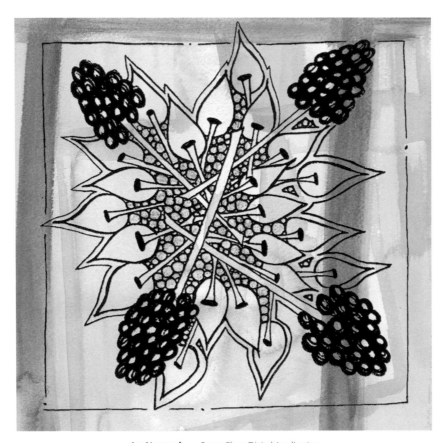

Au Naturale · *Bronx Cheer* Digital Application
watercolor background, Adobe Photoshop (*Darken*, Layer Blending Mode)

Visit www.createmixedmedia.com/zentangleuntangled for extras.

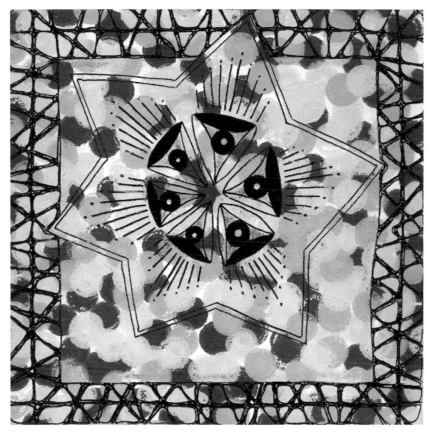

Tripoli Star · *Tripoli* Digital Application
acrylic paint, Adobe Photoshop (*Linear Burn*, Layer Blending Mode)

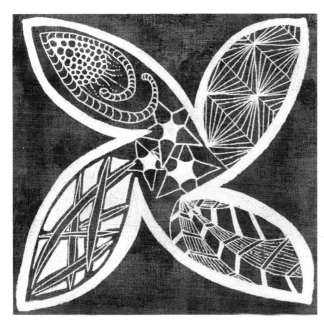

Orange Blossom
acrylic paint, Adobe Photoshop (*Divide*, Layer Blending Mode)

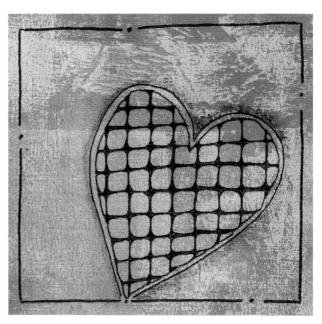

iHeart · *iHeart* Digital Application
acrylic paint, ink, Adobe Photoshop (*Linear Burn*, Layer Blending Mode)

Sign up for the free newsletter at www.createmixedmedia.com.

105

Remember this tangle?
Paradoxical, *using* Rick's Paradox *tangle*

(In the Beginning, *Chapter 1*).

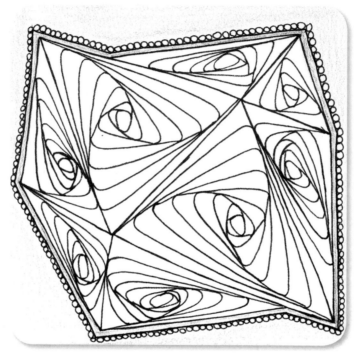

Paradoxical · Sakura Pigma Micron pens

Here it is using the same background

These two digital works originate from the same background. One uses the *Darken* feature, one uses the *Exclusion* feature. Playing with Adobe Photoshop is one of the best ways to learn how to use the program and its capabilities. As you can see, one change in choice can create a very different piece of art.

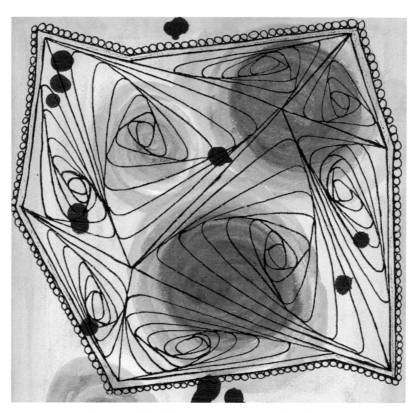

Betwixt · *Paradoxical* Digital Application · water-soluble oil pastels, ink,
Adobe Photoshop (*Darken*, Layer Blending Mode)

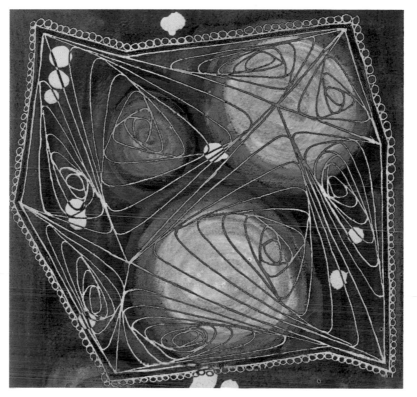

Betweed · *Paradoxical* Digital Application · water-soluble oil pastels, ink,
Adobe Photoshop (*Exclusion*, Layer Blending Mode)

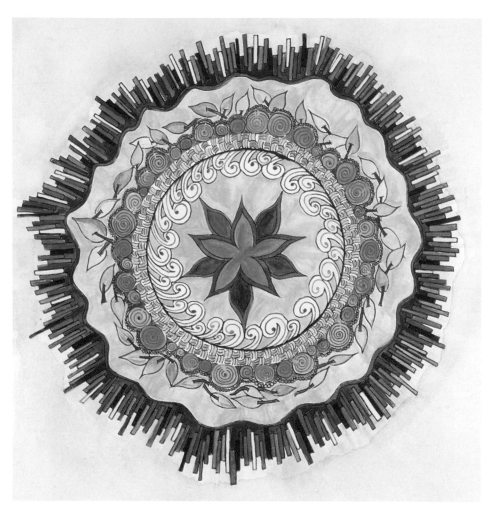

Zendala · Sakura Pigma Micron pen, watercolor

This Zendala was one of the first pieces I created for this book—I had no idea where it was headed, I just drew. When it was simply black and white, it was impressive but something was missing, so I pulled out my trusty watercolors and worked from the inside out. Although there was no planning involved, in remains one of my favorite Zentangle artworks.

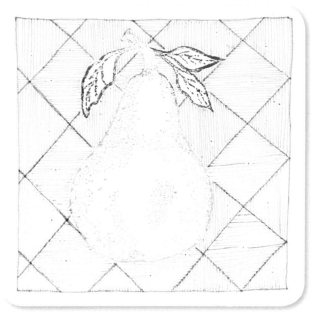

Peary Nice · stamp-The Artful Stamper, Tim Holtz Distress Ink,
Copic Multiliner pen

I love this pear stamp and knew it would look fantastic with a simple background tangle behind it. To continue with the muted tones of the Distress Ink pads, I chose a gray, Copic pen instead of the Sakura black, so as not to overwhelm the softer colors.

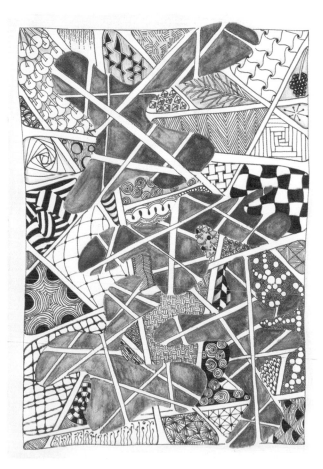

Graphtint Maze · Sakura Pigma Micron pen, Derwent Graphtint pencils

This piece really is a tangle within a tangle. It utilizes the pattern *Hollibaugh*, which teaches the artist to "draw behind."

Starting with four splat shapes, I tangled inside each one and colored them using Derwent Graphtint pencils. Then, I started a new tangle (still *Hollibaugh*) to work around the splats. I drew other official tangle patterns in the outer tangle.

How many different patterns can you see?

Sign up for the free newsletter at www.createmixedmedia.com.

109

Zentangle Gallery

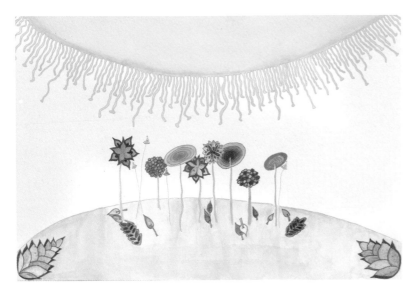

Instead of using a black Sakura pen, I decided to use colored Sakura Pigma Microns and color them with watercolor paints. The effect is you can still see the tangles within the work but the various color shades bring a fun, whimsical feel to the work.

Spring Garden · watercolor, colored Sakura Pigma Micron pens

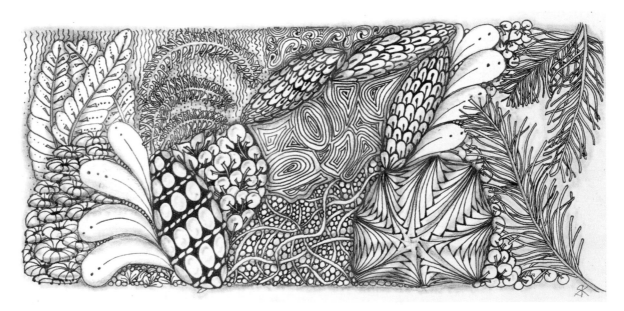

Woven Wonder Tile · Sakura Pigma Micron pen, graphite pencil

by Beckah Krahula, CZT

This Zentangle-inspired work by Beckah Krahula utilizes many tangles. There is a strong sense of garden or forest in this piece, worth exploring!

Visit www.createmixedmedia.com/zentangleuntangled for extras.

Life is pretty awesome right now. Our marriage is stronger than ever, our family is happy and healthy and we feel so happy in our working lives. All I want now is some sunshine! I feel so blessed to be healthy and alive and chasing my dreams — I love the artistic life and the freedom to be the person I am. I am lucky. I am priviledged. I am Kass. Life is *Joy*

Life · Sakura Pigma Micron pen, colored pencil

Life has been pretty good to me, despite the ups and downs. When I was sitting in my studio last winter, all I could wish for was some sunshine. This playful Zentangle reflects my mood when the sun is shining: happy, playful, content.

A Christmas tree covered in Zentangle ornaments—I can only imagine how cool that would look. Maybe a project for next year?

Tree Ornament · MDF tree ornament, acrylic paint, Sakura Pigma Micron pen, cord

by Geneviève Crabe, CZI

Sign up for the free newsletter at www.createmixedmedia.com.

111

Zentangle Gallery

Another two versions of the triptychs from Geneviève Crabe, CZT; the original black and white and the fiery red and yellow. These are fantastic side-by-side because you get a feel for how color can add to your Zentangle work, but also appreciate the class of the traditional method.

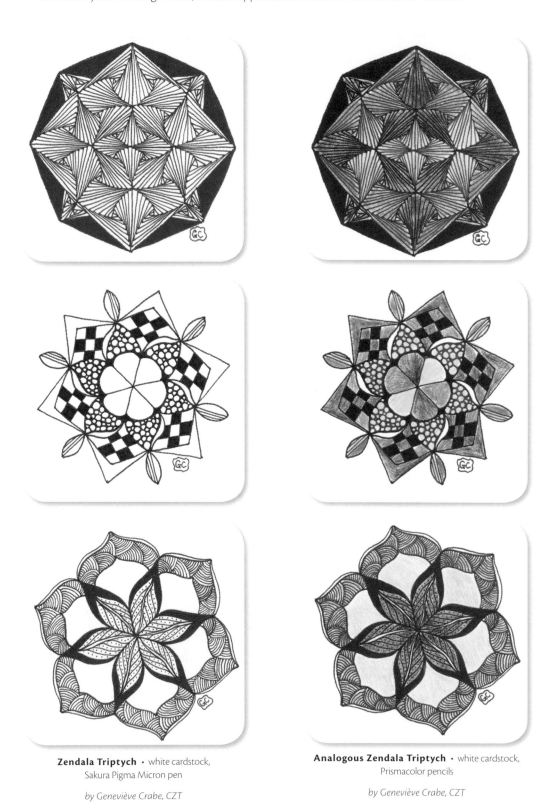

Zendala Triptych · white cardstock,
Sakura Pigma Micron pen

by Geneviève Crabe, CZT

Analogous Zendala Triptych · white cardstock,
Prismacolor pencils

by Geneviève Crabe, CZT

Opus · Sakura Pigma Micron pen

Recognize this cover girl? Opus, an official Zentangle® tangle, is one of my favorites and one I built upon for several pieces throughout the book.

Sparkles · Sakura Pigma Micron pen, graphite pencil

by Chari-Lynn Reithmeier, CZT

The way Chari-Lynn Reithmeyer, CZT, has used color as an accent to her tangle, rather than coloring it completely, makes this an exciting Zentangle. It inspires me to feel magical, like fairy-dust has been sprinkled all through the pages.

Sign up for the free newsletter at www.createmixedmedia.com.

113

Zentangle Gallery

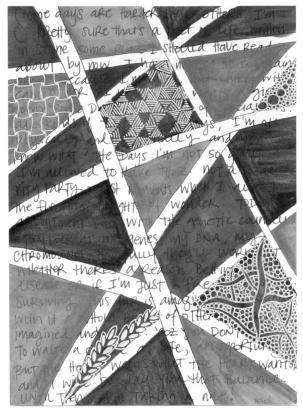

Some Days · Sakura Pigma Micron pen,
Sakura Gelly Roll pen, acrylic paint

This is a classic art journal page for me. It's not unusual for me to write out my feelings about issues and then paint right over it; I've expressed myself without revealing my thoughts to the world. In this case, I used *Hollibaugh* to draw right over the top of my words then acrylic paint to fill in so there was a glimpse of my journal entry, but not enough to really read. When the paint was dry, my white Sakura Gelly Roll pen was just the thing to add some further tangle accents.

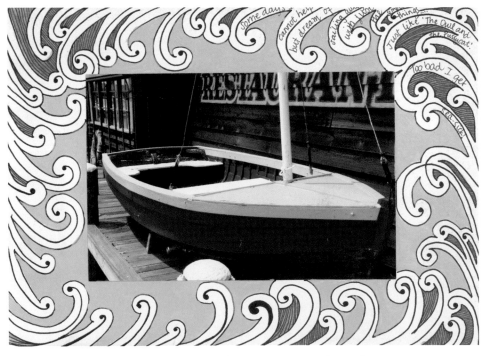

Sail Away · acrylic paint, Sakura Pigma Micron pen, photography

I took myself to the bayside Melbourne suburb of Williamstown on a photography excursion and when I saw this boat outside a restaurant, I immediately thought of the official Zentangle® pattern *Floo*. The bright colors of the boat inspired the coloring of the tangle; it has a real pop art feel to it.

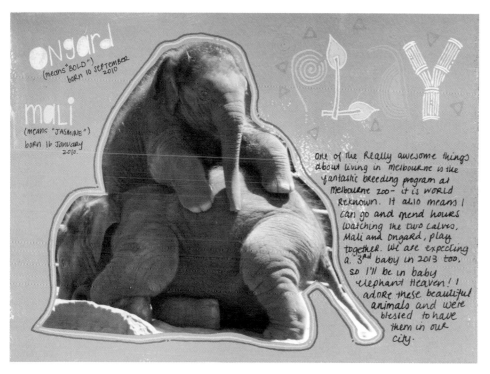

Within the image:
ONGARD
(means "BOLD")
born 10 September 2010

MALI
(means "JASMINE")
born 16 January 2010.

PLAY

One of the really awesome things about living in Melbourne is the fantastic breeding program at Melbourne Zoo - it is world reknown. It also means I can go and spend hours watching the two calves, Mali and Ongard, play together. We are expecting a 3rd baby in 2013 too, so I'll be in baby elephant Heaven! I adore these beautiful animals and we're blessed to have them in our city.

Play · acrylic paint, Sakura Souffle pens, Sakura Pigma Micron pen, photography

This journal page really is about Mali and Ongard, the baby elephants at Melbourne Zoo. I am an elephant lover and I sponsor an orphan elephant in Kenya. As I sat for many hours one day, watching them play, I felt so much joy and happiness that these precious animals will eventually help rebuild elephant numbers in the wild. I wanted my journal page to reflect that playfulness and joy and I used different tangles and colors in the page title to create this sense of fun.

Trapped Heart · Sakura Pigma Micron pen, watercolor pencils

This simple image would make a great page accent on a journal page, perhaps something reflecting on true love, or lost love?

Sign up for the free newsletter at www.createmixedmedia.com.

115

Zentangle Gallery

Outback Gold · Tim Holtz Distress Stain, Sakura Pigma Micron pen

When I first started using Tim Holtz Distress Stains, I wanted a different way to apply them than the bottles they came in, so I poured the ink into misters and sprayed. I used two different colors on a Zentangle tile, then used *Hollibaugh* (again!), but instead of drawing it the usual way, I used official tangle *Zander* as my lines.

Blue Fleur · Sakura Pigma Micron pen, colored paper, Sakura Gelly Roll pen, Flourish stencil

by Geneviève Crabe, CZT

Geneviève Crabe, CZT, used a stencil to get the outline of this flourish. What a great way to achieve shape! What stencils do you have that might lend themselves to being tangled?

Visit www.createmixedmedia.com/zentangleuntangled for extras.

This page came about when I found this rubber stamp, because it reflects the Zentangle attitude to drawing—we don't use erasers, because life doesn't have erasers! The stamp didn't imprint as sharply as I would have liked, but I included it in the book anyway because it reflects exactly the stamp (and Zentangle) sentiment: Just because it isn't perfect doesn't mean it's not beautiful.

Life Is Art · Sakura Pigma Micron pen, Prismacolor marker, ink, rubber stamp, Derwent Inktense pencil, watercolor paint

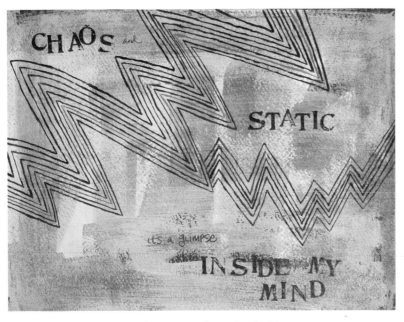

Another journal page reflecting my state of mind on any given day: some days you feel like the static of a television is actually what's happening in your brain! The tangle *Static* was a simple way to journal that day's feeling.

Static In My Head · acrylic paint, ink

Sign up for the free newsletter at www.createmixedmedia.com.

117

Digital Zentangle Gallery

Part of encouraging the experimentation process is trying different things and seeing what works for the artist, which is what I did with all of these digital pieces. Have fun playing!

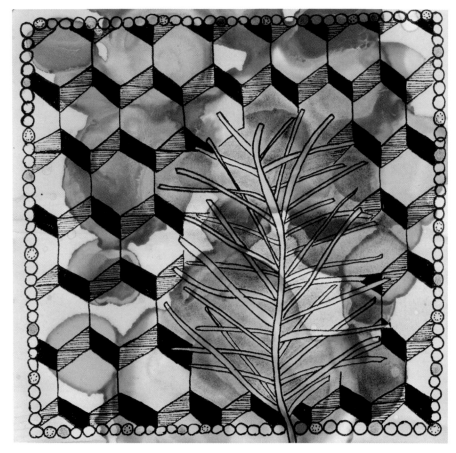

Digital Honeycomb · Alcohol ink, watercolor paint, Sakura Pigma Micron pen, Adobe Photoshop (*Darken*, Layer Blending Mode)

Looking Glass · Acrylic paint, Sakura Pigma Micron pen, Adobe Photoshop (*Darken*, Layer Blending Mode)

Digital Opus · Acrylic paint, ink, Sakura Pigma Micron Pen, Adobe Photoshop (*Darken*, Layer Blending Mode)

Visit www.createmixedmedia.com/zentangleuntangled for extras.

Stinger Net · acrylic paint, Sakura Pigma Micron pen,
Adobe Photoshop (*Divide*, Layer Blending Mode)

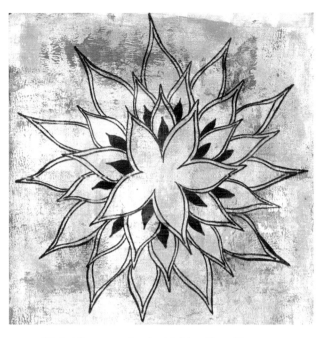

Digital Cyme · acrylic paint, ink, Sakura Pigma Micron pen,
Adobe Photoshop (*Darken*, Layer Blending Mode)

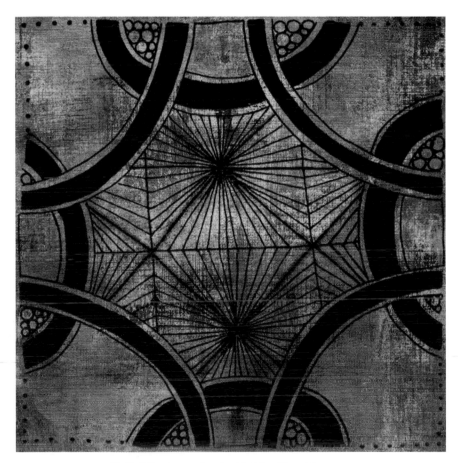

Digital Facets · acrylic paint, ink, Sakura Pigma Micron pen,
Adobe Photoshop (*Linear Burn*, Layer Blending Mode)

Sign up for the free newsletter at www.createmixedmedia.com.

119

Chari-Lynn Reithmeier, CZT
www.charilynn.com

Chari-Lynn is a three-year Honors Graduate of Georgian College, School of Design and Visual Arts. She creates all types of art from her studio in Collingwood, Ontario, Canada. An active Certified Zentangle® Teacher, Chari-Lynn also teaches workshops in Artist Trading Cards, Crazy Quilting, Embroidery, Beading and Felting, and is currently working on a series of mixed-media art dolls.

Melissa Hoopes, CZT
www.stampassion.com

Melissa is a Certified Zentangle® Teacher and the owner of Stampassion.com, a paper arts web store, specializing in tangling supplies, rubber art stamps and dies. She lives in the Saratoga, New York area with her husband, Dan, and two rambunctious cats.

Sue Clark, CZT
www.tangledinkart.blogspot.com

Sue is a Certified Zentangle® Teacher living in Loveland, CO. She had the pleasure of meeting Kass at the CZT4 certification class in October of 2010. Sue is having so much fun sharing the Zentangle art method with others.

KathyAnne Whittemore
www.LivingDifferentlyNow.com

Now a Southwest USA resident, KathyAnne is dedicated to living differently and expansively with the new world that's emerging, keeping anchored in the "ordinary" of nature as well as the healing zen of the art-making process.

Nancy Miller Pinke, CZT
pinke.freeyellow.com

Nancy's art career was inspired by her mother who encouraged her to be creative when still in a highchair. She has a Bachelor of Science degree in Art Education from Winona State University and has had her studio in her Minnesota home for thirty years. She primarily paints animals in oil, watercolor and sculpture—and some Zentangle, too!

 z e n t a n g l e ®

Zentangle®
www.zentangle.com

The Zentangle method is a way of creating beautiful images from structured patterns. It is fun and relaxing. Almost anyone can use it to create beautiful images. Founded by Rick Roberts and Maria Thomas, the Zentangle method helps increase focus and creativity, provides artistic satisfaction along with an increased sense of personal well-being and is enjoyed all over this world across a wide range of skills, interests and ages. For more information, please visit our website.

Geneviève Crabe, CZT
www.amarylliscreations.com

Following a thirty-year career in high-tech, Geneviève is now a full-time artist, teacher and blogger living in in St. Thomas, Ontario, Canada. She is a Certified Zentangle® Teacher and creator of Tangle Organizers and Tangle Journals. Her interests include mixed-media art, beadwork, and pen-and-ink drawing.

Beckah Krahula
www.beckahkrahula.com

Beckah Krahula is a mixed-media artist, national and international teacher, author, designer and product developer. She became a CZT in 2011, and her book *One Zentangle a Day* will be released fall 2012. Check out her blog for new Zentangle tiles, ZIAs, tangled journaling and mixed-media projects.

Sign up for the free newsletter at www.createmixedmedia.com.

121

These are books I own and blogs I read regularly. I have found them useful in my own art journaling process, both for learning and inspiration. You might like them, too.

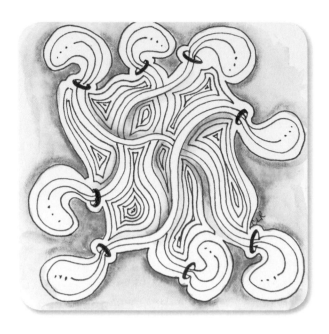

Books

Eric M. Scott and David R. Modler
The Journal Junkies Workshop

Linda Woods and Karen Dinino
Visual Chronicles and **Journal Revolution**

Sarah Ahearn Bellemare
Painted Pages

Traci Bunkers
The Art Journal Workshop

Kelly Rae Roberts
Taking Flight

Dawn DeVries Sokol
1,000 Artist Journal Pages

Dan Eldon
The Journey Is the Destination

Danny Gregory
An Illustrated Life and **The Creative License**

Lynne Perrella
Artists' Journals & Sketchbooks

Richard Brereton
Sketchbooks

Mordy Golding and John Ray Sams
Teach Yourself Adobe Creative Suite 3 All in One

Jill K. Berry
Personal Geographies: Explorations in Mixed-Media Map Making

Traci Bautista
Collage Unleashed and **Doodles Unleashed**

Cathy Johnson
Artist's Journal Workshop

Mike Perry
Over & Over

Blogs

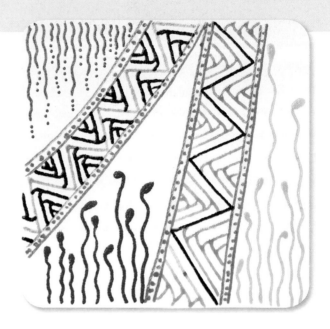

Alisa Burke
www.alisaburke.blogspot.com

Danny Gregory
www.dannygregory.com

Jane Davenport
www.janedavenport.com

Kelly Rae Roberts
www.kellyraeroberts.blogspot.com

Liesel Lund
www.liesel.typepad.com

Lisa Cheney-Jorgensen
www.lisacheneyjorgensen.blogspot.com

Traci Bunkers
www.TraciBunkers.com/blog

Pam Garrison
www.pamgarrison.typepad.com

Samantha Kira Harding
www.journalgirl.com

Fran Meneley
www.franmenley.typepad.com

Jill K. Berry
www.jillberrydesign.com

Misty Mawn
www.mistymawn.typepad.com

Traci Bautista
www.kollaj.typepad.com

Teesha Moore
www.teeshascircus.com

Journal Fodder Junkies
www.journalfodderjunkies.blogspot.com

Illustration Friday
www.illustrationfriday.com

Pat Pitingolo
www.patpitingolo.blogspot.com

Urban Sketchers
www.urbansketchers.org

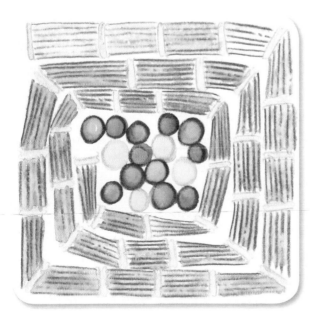

Sign up for the free newsletter at www.createmixedmedia.com.

123

The following companies manufacture products featured in this book. Please check your local retailers to find these materials, or go to a company's website for the latest products. In addition, we have made every attempt to properly credit the items mentioned in this book. We apologize to any company that we have listed incorrectly, and we would appreciate hearing from you.

About Zentangle®:

The name "Zentangle" is a registered trademark of Zentangle Inc.

The red square logo, the terms "Anything is possible one stroke at a time", "Zentomology" and "Certified Zentangle Teacher (CZT)" are registered trademarks of Zentangle Inc.

It is essential that before writing, blogging or creating Zentangle Inspired Art for publication or sale that you refer to the legal page of the Zentangle website.

www.zentangle.com

Adobe Photoshop
www.adobe.com/products/photoshop

Derwent Pencils
www.pencils.co.uk

Dick Blick
www.dickblick.com

Faber-Castell
www.faber-castell.com

Golden Paints
www.goldenpaints.com

Tim Holtz
www.timholtz.com

Moleskine
www.moleskine.com

Prismacolor
www.prismacolor.com

Ranger Industries
www.rangerink.com

Sakura of America
www.sakuraofamerica.com

Strathmore Artist Papers
www.strathmoreartist.com

Tsukineko
www.tsukineko.com

Index

Sign up for the free newsletter at www.createmixedmedia.com.

125

Kass Hall is a mixed-media artist

and instructor from Melbourne, Australia, who has explored many art forms over the years, including scrapbooking, painting, sculpture and graphic design. Her current art focuses on art journaling and drawing with an emphasis on Zentangle. Kass has a Bachelor of Visual Art and Graduate Diploma in Secondary Education and is now working toward a Master of Visual Arts at Monash University. She is also a Certified Zentangle® Teacher. Her work has been published in *For Keeps Scrapbooking, Scrapbooking Memories Australia, Scrapbook Creations* and *Cloth Paper Scissors Studios.*

Acknowledgments

I would like to start by thanking Maria Thomas and Rick Roberts for creating and sharing Zentangle® with the world and their unfailing love and support to me. Their generosity knows no limits.

My deepest thanks to Bethany Anderson, my fearless editor and the team at North Light for their superb work on this book. Special thanks to Tonia Davenport for her belief in this project from the very beginning.

To Chari-Lynn, KathyAnne, Beckah, Genevèive, Nancy, Melissa and Sue: Thank you for contributing your creativity to this book and coming to my rescue at my greatest time of need.

Thank you to my friends and family for their support of me while I created this book. I hope it makes you proud.

Visit www.createmixedmedia.com/zentangleuntangled for extras.

17 16 15 14 10 9

www.fwmedia.com

DISTRIBUTED IN CANADA BY FRASER DIRECT

100 Armstrong Avenue

Georgetown, ON, Canada L7G 5S4

Tel: (905) 877-4411

DISTRIBUTED IN THE U.K. AND EUROPE BY F&W MEDIA INTERNATIONAL

Brunel House, Newton Abbot, Devon, TQ12 4PU, England

Tel: (+44) 1626 323200, Fax: (+44) 1626 323319

Email: enquiries@fwmedia.com

DISTRIBUTED IN AUSTRALIA BY CAPRICORN LINK

P.O. Box 704, S. Windsor NSW, 2756 Australia

Tel: (02) 4577-3555

SRN: W5533

ISBN-13: 978-1-4403-1826-9

ISBN-10: 1-4403-1826-3

Edited by Bethany Anderson

Designed by Julie Barnett

Production coordinated by Mark Griffin

Photography by Al Parrish

Metric Conversion Chart

TO CONVERT	TO	MULTIPLY BY
inches	centimeters	2.54
centimeters	inches	0.4
feet	centimeters	30.5
centimeters	feet	0.03
yards	meters	0.9
meters	yards	1.1

Adobe® Photoshop® are either registered trademarks or trademarks of Adobe Systems Incorporated in the United States and/or other countries.

Adobe product screen shots reprinted with permission from Adobe Systems Incorporated.

Sign up for the free newsletter at www.createmixedmedia.com.

127